DER
BLAUE REITER

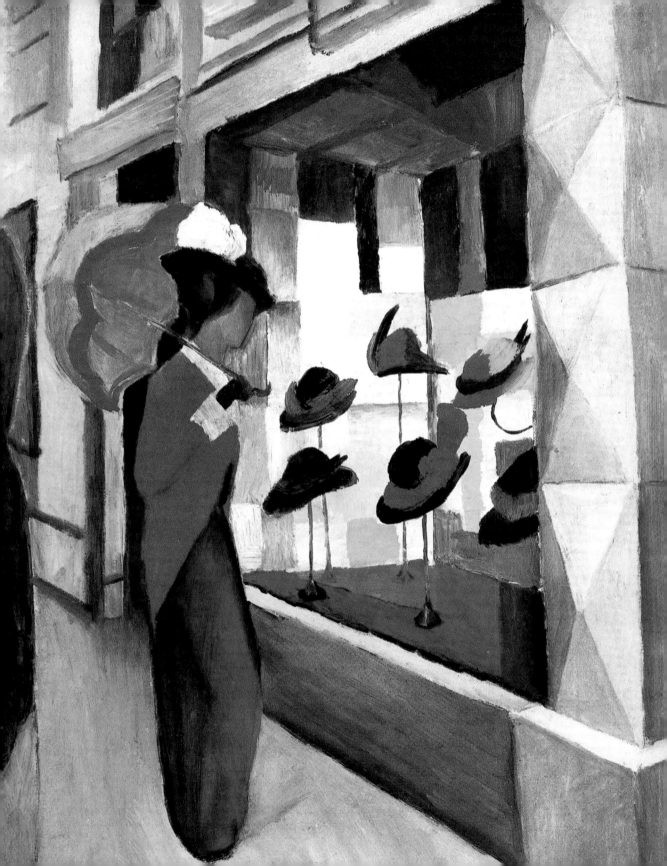

expressionism

NORBERT WOLF
UTA GROSENICK (ED.)

TASCHEN

KÖLN LONDON LOS ANGELES MADRID PARIS TOKYO

contents

metaphysical german meatloaf

1) MATTHIAS GRÜNEWALD

<u>The Crucifixion</u>
from the Isenheim Altarpiece
between 1512 and 1516, Oil on wood panel,
269 x 307 cm
Colmar, Musée d'Unterlinden

2) WASSILY KANDINSKY

<u>Improvisation 9</u>
1910, Oil on canvas, 110 x 110 cm
Stuttgart, Staatsgalerie Stuttgart

"What does my shadow matter? Let it run after me! I – shall outrun it …" This proud credo was penned in the 1890s by Friedrich Nietzsche (1844–1900), in *Thus Spake Zarathustra*. Twenty years later, Expressionist artists took the philosopher they idolized at his word and outran the shadow of academic rules, bourgeois taste, and the backward-looking costume plays of Historical Revival art.

The words "expressionism" and "expressionist" first cropped up in the art literature around 1911, initially as blanket terms for avant-garde art in Europe around the turn of the century. Paul Cassirer (1871-1926), the Berlin art dealer, reputedly applied the term to the emotion-charged paintings and prints of Edvard Munch (1863–1944), in order to distinguish the Norwegian's work from Impressionism. The same word was used by art historian Wilhelm Worringer (1881–1965), in the journal *Sturm* for August 1911, to characterize the art of Paul Cézanne (1839–1906), Vincent van Gogh (1853–1890) and Henri Matisse (1869–1954). In the catalogue to the Berlin Secession exhibition of 1911, Cubist and Fauvist artists fell under this rubric, from Pablo Picasso (1881–1973) to the young French vanguard. In Herwarth Walden's (1879–1941) book of 1918, *Expressionismus, die Kunstwende* (Expressionism, the Turning Point in Art), Italian Futurists, French Cubists and the Blauer Reiter in Munich were all subsumed under this term. Yet five years previously, at the "First German Autumn Salon" of 1913, Walden had introduced the Blauer

Reiter group as "German Expressionists", and thus limited this stylistic category to the German-speaking countries.

This tendency would soon become the rule. A breakthrough in this regard was Paul Fechter's (1880–1958) 1914 book, *Der Expressionismus,* which focused on the art of Die Brücke and Der Blaue Reiter. In the field of literature, too, the term became current around 1911, and a year later, the first "German Expressionist drama" was staged, in the shape of Walter Hasenclever's (1890–1940) play *Der Sohn* (The Son).

By the outbreak of the First World War, in other words, Expressionism had become almost synonymous with the German contribution to current international developments in art and literature. This national restriction took place despite the great and obvious impulses that German art received from abroad. Although many on the German scene denied such influences, cosmopolitan artists like the Russian El Lissitzky (1890–1941) and Hans (Jean) Arp (1887–1966) of Alsace saw them very clearly, while scoffing that German artists had only half-digested them. In their book *The Art Isms,* 1925, the two authors declared, "Cubism and Futurism were minced up to create mock hare, that metaphysical German meatloaf known as Expressionism."

Nevertheless, the myth had long since been born; or perhaps rather, a myth that had existed since the *Sturm und Drang* of the late

1905 — Russo-Japanese War ends with Japan's victory 1905 — Robert Koch receives Nobel Prize in Medicine for his tuberculosis research
1906 — In France, the Jewish officer Alfred Dreyfus, accused of treason, is rehabilitated

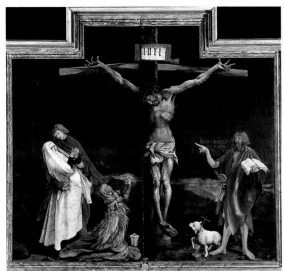

eighteenth century had received fresh fuel: the supposed prerogative of Germans for the expression of extreme emotional states in art.

Now, about 1905, German artists appeared to be bringing what were seen as their Faustian gifts into modern art with revolutionary verve, finally establishing a counterweight to the French avant-garde. And since it was supposedly an outpouring from the national psyche, Expressionism could be explained in language like this: "German man is demonic man per se … Driven, buffeted by such a demonism of Becoming and never Being – this is how the German appears to other peoples." So stated the idealist philosopher Leopold Ziegler (1881–1958), in *Das Heilige Reich der Deutschen* (The Holy Empire of the Germans), published in 1925. Back in 1920, the creative urge spurred by such mental "buffeting" was evoked by the former Brücke painter Max Pechstein. In a similarly agitated staccato, Pechstein exclaimed: "Work! Intoxication! Brain racking! Chewing, eating, gorging, rooting up! Rapturous birth pangs! Jabbing of the brush, preferably right through the canvas. Trampling on paint tubes …" Shock, provocation, a revolt of the young against the hidebound establishment – these, not only Pechstein believed, were the driving force behind Expressionism.

A feverish restlessness, an emphasis on the painting process rather than on the creation of serene, self-contained form, a tendency to mysticism – elements of the "German psyche" that seemed to predestine it for the new style. "The Expressionist does not look, he sees,"

declared Kasimir Edschmid; that is, Expressionist artists were formative rather than imitative minds who shaped their view of the world out of their own volition, who in effect "created" reality by dint of their visionary powers.

Judging by such examples, Expressionist diction with its telegram style, its exclamations and explosive, brief phrases not only blasted traditional syntax but apparently conveyed clear and lucid ideas. Yet this impression is deceptive. In reality, it inflated the metaphysical meaning of words, generated arbitrary verbal sequences, and – charged with symbols and metaphors – remained purposely dark and obscure, comprehensible only to initiates. The exalted, harsh character of Expressionist diction was in fact an elixir for those involved in the movement. But it also invited criticism. As August Macke already told some of his fellow painters, the means of expression they used were perhaps "too-big for what they wanted to say".

What would be gained by taking Expressionism at its word and raising the expression of emotions to the main criterion of good art? Wouldn't this be tantamount to exalting a mania into a style? What is implied by describing the effect of art metaphorically, as a slap in the public's face, an attack on the audience? In 1917 Herwarth Walden gave a terse definition of Expressionist art, saying that it was not an "impression from outside" but an "expression from inside." Yet again, this definition is not so apt as it might seem. When we think about it, it

1906 — San Francisco hit by a devastating earthquake, killing about 80,000 of its 120,000 inhabitants. In Siberia, a giant meteorite causes widespread devastation

1908 — Messina destroyed by an earthquake,

7

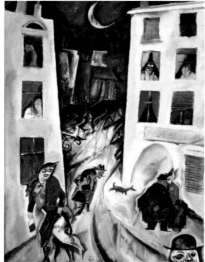

3) FRANZ MARC
<u>Fighting Forms</u>
1914, Oil on canvas, 91 x 131.5 cm
Munich, Pinakothek der Moderne –
Staatsgalerie Moderner Kunst

4) GEORGE GROSZ
<u>The Street</u>
1915, Oil on canvas, 45.5 x 35.5 cm
Stuttgart, Staatsgalerie Stuttgart

applies just as well to countless past works of art, from the figures of Michelangelo to the prints of Albrecht Dürer, or from the altar paintings of Matthias Grünewald (c. 1475/80–1528; fig. 1) to the work of El Greco (c. 1541–1614), two artists much admired by the Expressionists. What justifies us in characterizing the expressiveness of early twentieth-century German modernism not simply as a neurotic adventure but as a serious "ism", an established style?

Art historians have always had their difficulties in accepting Expressionism as a style. One need only compare the paintings of Kirchner, Kandinsky, Kokoschka and Dix to see that they have next to no formal common ground. This is why many art historians now prefer to describe Expressionism less as a style than as a "direction" or "tendency", a manifestation of a young generation's feeling for life. This art can just as much be suffused by urban anxiety as reflect nostalgia for a past Golden Age, a paradisal state of innocence. And as frequently as the Expressionists probed new and suggestive forms within the force field of modern art, they just as frequently thought through old and familiar formulas, bringing them up to date, developing them to a radical peak – suggesting that they were not able to outrun that "shadow" invoked by Nietzsche after all.

In fact, Nietzsche himself loomed like a shadow over them. His books were enthusiastically consumed by the younger generation, especially *Zarathustra*. The revolutionary philosopher presented a prime example of self-liberation from authoritarian constrictions, bourgeois narrow-mindedess, materialist thinking. As the poet Gottfried Benn (1886–1956) would later recall, Nietzsche "… was the earthquake of the epoch for my generation." Yet such an overweening "superego" also presented countless problems to Nietzsche's enthusiastic disciples. The two most important artists' groups that appeared in Germany in the years prior to the First World War, Die Brücke and Der Blaue Reiter, attempted nothing less than to realize the ideal of a future existential world order. In their manifesto, the Brücke artists appealed to a "new generation of both creators and lovers of art", to anyone who was capable of expressing "what urges them to create, directly and without adulteration", as welcome adepts of a new and progressive religion of art.

Between Distortion and Abstraction

The dogmas of this art, this religion of art with its projection of a good and true life, were fraught with contradictions. On the one hand stood means of extreme subjectivity; on the other, a desire for individual immersion in and submission to the cosmos. This was reflected in the characters in Expressionist literature, stage plays and art, who acted as if they were marionettes of universal forces. The

1909 — The first six-day bicycle race in Germany takes place in Berlin 1910 — Sigmund Freud publishes his pioneering essay,
"On Psychoanalysis" 1911 — German gunboat "Panther" is sent to Agadir, triggering the second Morocco Crisis

8

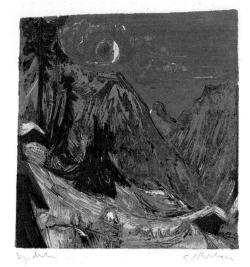

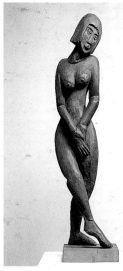

5) ERNST LUDWIG KIRCHNER

<u>Winter Moon Night</u>
1919, Colour woodcut, 31 x 29.5 cm
Basel, Öffentliche Kunstsammlung,
Kupferstichkabinett

6) ERNST LUDWIG KIRCHNER

<u>Standing Female Figure</u>
1912, Wood (alder), 98 x 23 x 18 cm
Berlin, Staatliche Museen zu Berlin –
Preussischer Kulturbesitz, Nationalgalerie

5 6

spontaneous, agitated expression aimed at in both cases led to what Werner Hofmann has called "elementary gestures of sensation and instinct".

At the onset of the development, the crucial thing was to overcome passive depictions of nature à la Impressionism and tap individual emotional powers, by employing brash bright colours and "brutally" reduced forms. The laws of perspective, faithfulness to anatomy, natural appearances and colours counted for little or nothing; distortion and exaggeration became an equivalent for rendering the material world transparent to the psyche. *On the Spiritual in Art* was the revealing title Kandinsky gave to the now-famous book he finished in 1910 and published in 1911. The development of an art of the psyche, what Kandinsky termed "spiritualization", opened to painting the realm of abstract symbolism, a turning point in art history for which both Kandinsky (fig. 2) and the Blauer Reiter in Munich (fig. 3) stood.

"Nordic man", who yearned for insight into the spiritual and, in that regard, was related to "the Oriental", explained Worringer in his 1908 dissertation *Abstraction and Empathy* "feels a veil between himself and nature," and therefore strives for an abstract art. Accordingly, abstraction and expression would enter a "Faustian" marriage.

Not only with regard to the ecstatically heightened self-consciousness of artists, but also with regard to their symbolic interpretation of the world, their search for metaphysical foundations or cosmological orders, utopian designs and elementary realms beyond history from which they hoped for a rebirth of unadulterated creativity, the Expressionists developed many an idea that originated in German Romanticism. Some of them were quite aware of this. Kandinsky, for instance, was greatly pleased when a critic used the term "Romanticism" in connection with his work. Moreover, Expressionism shared the penchant of one branch of Romanticism for things dark and aberrant.

A case in point is Alfred Kubin (1877–1959), an eccentric artist distantly associated with the movement. Born in Leitmeritz (now Litomerice) in Bohemia, the young Kubin enjoyed torturing small animals, watched flayers and butchers at work, and was fascinated by natural disasters – probably an instinctual reaction to an overly strict father. In 1911 Kubin was among the founding members of Der Blaue Reiter. Years previously he had illustrated ghost and horror tales by the likes of Dostoyevsky, E.T.A. Hoffmann, Edgar Allan Poe, and Oskar Panizza, primarily in pen-and-ink drawings, but occasionally in watercolours or oils. Kubin's spidery, scratchy stroke invoked a phantasmagorical and nightmarish realm that seemed to spring straight from the "black" or "gothic" Romanticism of the early nineteenth century. In twelve weeks of the year 1907, he wrote the novel *The Other Side,* a paraphrase of the Apocalypse in highly expressive diction. Kubin spirits the reader into a dream city by the name of Pearl, in far distant

1911 — Marie Sklodovska-Curie awarded Nobel Prize in Chemistry for her discovery of radium and polonium 1911 — Roald Amundsen becomes first man to reach the South Pole 1912 — Passenger ship "Titanic" sinks after colliding with an iceberg

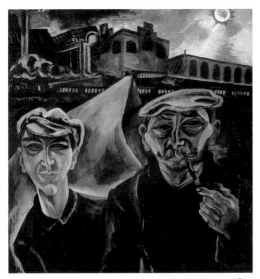

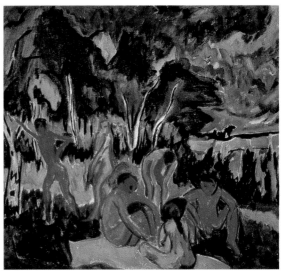

7

8

Asia. As the inhabitants search for a hidden meaning in the sense-lessness of their existence, the devil appears among them in the guise of a "manager" and takes over the helm. The plot turns and the city begins its inexorable demise.

Overexcitedness was characteristic not of all but of many fields of Expressionist activity. Recall the agitated figures in Nolde's religious compositions, the apocalyptic landscapes of Schmidt-Rottluff, Heckel, and especially Meidner, or the masklike, distorted big-city faces of Grosz (fig. 4) or Dix. Overexcitedness also marks the highly contrasting planes or nervous, angular forms and hatching in the prints, many of which are among the high points of Expressionist art (fig. 5). An aesthetic of the ugly and brutal came to the fore. This represented an appeal on artists' part to liberate art from the ghetto of the "beautiful and true", where it had degenerated into pretty, innocuous decoration for home and fireside. This aesthetic went hand in hand with an urge for the "elemental", everything exotic and primitive, which along with free sexuality were celebrated as an embodiment of "naturalness" and the lust for life of Expressionist creation.

As early as 1905, French avant-garde artists had begun to interest themselves in ethnological collections and adorned their studios with African masks and statues from the South Pacific. This desire for supposed primitiveness served two purposes for bohemians: as a way to revolt against the bourgeoisie, and as a source of pre-sumably unspoiled principles of design, embodied in the art of the world's indigenous peoples. Masks, fetishes, ancestor figures – along with folk art, children's drawings and the picturemaking of the mentally ill – advanced to the centre of artists' concerns. Nolde set off in 1913 on an expedition to New Guinea. Pechstein considered settling in the Palau Islands in 1914. Aesthetically, such interests resulted not least in a number of Expressionist carvings. Schmidt-Rottluff's wood sculptures were probably inspired by Carl Einstein's book *Negerplastik* (Negro Sculpture), published in 1915. Kirchner, too, created similar works (fig. 6). Museums of ethnology became sources of Expressionist inspiration, as did the performances of "exotic artistes" at the circus or cabarets, or magazine photographs of "Negro combos". Primitivistic traits entered depictions of faces especially, with angular noses, full lips and pointed chins, an emphasis on the roughhewn that was complemented by exaggerated gestures and poses.

Yet such excessive tendencies were always paralleled by more domesticated approaches. Kirchner's oeuvre can stand for many in this regard. Kirchner was not the sheer emotionalist for which he his generally taken. Especially after 1920, the intellectual underpinning of his art became increasingly important to him; he began to suppress the impulsive factor in favour of a more considered approach. The resulting decorative, flat structuring and serene, monumental compositions belied the cliché of the Faustian German modernism favoured by

1912 — Rudolf Steiner establishes the "Anthroposophical Society"
1912 — Portrait bust of Egyptian queen Nefertiti is unearthed, and the original is brought to Berlin

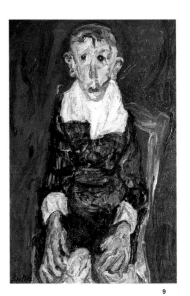

7) CONRAD FELIXMÜLLER
<u>Worker on the Way Home</u>
1921, Oil on canvas, 95 x 95 cm
Berlin, private collection

8) MAX PECHSTEIN
<u>Open air (Bathers in Moritzburg)</u>
1910, Oil on canvas, 70 x 79.5 cm
Duisburg, Wilhelm Lehmbruck Museum

9) CHAIM SOUTINE
<u>The Village Idiot</u>
1920/22, Oil on canvas, 92 x 65 cm
Avignon, Musée Calvet

many later authors, who accordingly disregarded this phase of his career and excluded it from the panorama of Expressionism.

Purging the world

In 1926, Ernst Jünger (1895–1989) described the mood on the eve of World War I in retrospect: "War simply had to bring us grandeur, strength, dignity. To us it seemed a masculine act, a merry shootout on blossoming, blood-bedewed meadows. No finer death was there in the world …" Only a few artists, including Pechstein and to some extent Grosz, Meidner and Felixmüller, were immune to this fascination. Barlach and Corinth, in contrast, added their voices to the patriotic choir. War euphoria swept through Europe from end to end.

The Futurists had long since declared war to be "the only hygiene for the world". Marc expected the war to bring a worldwide catharsis and a spiritual purging of humankind. Beckmann and Dix volunteered for service; Schmidt-Rottluff looked forward to the chance to "create something as powerful as could be". Yet such exalted visions rapidly gave way to trauma in view of the shell-holed fields, rank trenches, and overflowing field hospitals of France and Flanders. Many young artists – Marc, Macke, Morgner – were never to return.

Prior to the First World War, Expressionist experiments in form and colour reflected above all individual artists' mental states and moods. Only later did they turn clearly to social issues, depicting victims of war, pillorying social injustice or political repression. Now artists began to advance concrete arguments for improving the world. However, only a few, apart from Grosz and Felixmüller (fig. 7), were willing to go beyond the artist's role and engage in actual party politics.

The Expressionist groupings, whether more closely or more loosely knit, all envisaged a community of living and working that partook of Romantic ideals. Naturally they pursued more practical ends as well, especially that of making their work known through group exhibitions and publications. The Brücke painters in particular shared everything, from studios and models to painting materials, partly out of a lack of funds but mainly because fraternal cooperation meant a great deal to them. Living and working in town was interrupted in the summer months by extended country vacations, where they painted from life, swam in the nude, and generally enjoyed themselves with their models and girlfriends. This imitation of an innocent state of nature (fig. 8) reflected artists' yearning for that unity of art and life which had been among the demands of the avant-garde ever since the 1890s. This, too, was an attempt to purify a materialistic world by turning back to the utopia of an earthly paradise.

--

1913 — Premiere of Stravinsky's ballet _Le sacre du printemps_ (Rite of Spring) in Paris provokes a scandal
1913 — In the U. S., Ford introduces the assembly line into automobile production

--

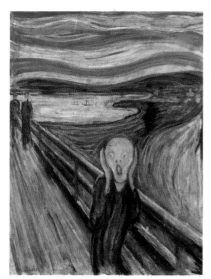

10) EDVARD MUNCH

<u>The Scream</u>
1893, Oil on canvas, 91 x 74 cm
Oslo, Nasjonalgalleriet

10

11) GEORGES ROUAULT

<u>Fallen Eve</u>
1905, Watercolour and pastel, 25.5 x 21 cm
Paris, Musée d'Art Moderne de la Ville de Paris

12) JAMES ENSOR

<u>Still-life in the Studio</u>
1889, Oil on canvas, 83 x 113 cm
Munich, Pinakothek der Moderne –
Staatsgalerie Moderner Kunst

The Topography of Expressionism

Many attempts have been made to divide the map of Expressionism into clear domains. As convincing as it is to focus on Dresden or Berlin (Die Brücke) and Southern Germany or Munich (Der Blaue Reiter), the attempt to define a Northern German group of Expressionists is problematical. The painters concerned barely knew each other, although Nolde had briefly met Paula Modersohn-Becker in Paris in 1900 and encountered Rohlfs in Soest in 1907. Otherwise the artists in the north lived at great distances from one another – Modersohn-Becker in Worpswede, Nolde mostly on the island of Alsen, and Rohlfs in Soest and Hagen. Nolde, in view of his brief, one-and-a-half year membership in Die Brücke, can properly be considered an affiliate of this tendency. Rohlfs, on the other hand, is described in the literature as a representative of "Rhenish Expressionism".

In purely geographical terms, the Rhineland in fact played an important part in the chorus of Expressionist voices. The Museum Folkwang, founded in Hagen in 1902 by Karl Ernst Osthaus (1874–1921), became a key centre of the art scene at that period. August Macke was active in the Rhineland on several occasions, serving in 1912, for instance, as a jury member for the Cologne "Sonderbund" exhibition. Yet the literature tends to put more weight on

Macke's contact with Der Blaue Reiter, which he maintained from Bonn and through his friendship with Marc. Actually, Macke's attitude to the Munich group was always ambivalent, and the romantic mysticism they displayed was not to his taste. Classifying Macke as part of Der Blaue Reiter is difficult, and is permissible only when we remain aware of his outsider's role. Yet it would be even more imprecise to consider Macke a leader in some specifically Rhenish brand of Expressionism. It was not until 1913, on the occasion of a show at the Cohen bookshop near Bonn University, where the key Expressionist ideologist Wilhelm Worringer taught, that Macke tried to marshal an existing group of friends under the title of "Rhenish Expressionists", and establish a third centre alongside Berlin and Munich. Yet there was no commonly held concept to weld together the sixteen candidates, who apart from Macke and Campendonk included the future Surrealist Max Ernst (1891–1976). The latter's characterization of the Bonn show in a newspaper review was indicative. The show revealed, Ernst wrote, "how a series of powers are at work within the great stream of Expressionism who have no outward similarity to one another but only a common 'direction' of thrust, namely the intention to give expression to things of the psyche *(Seelisches)* through form alone."

The Austrian and Viennese art scene was dominated around 1900 by Jugendstil, or Art Nouveau. Gustav Klimt (1862–1918) was

1914 — Assassination of Archduke Franz Ferdinand and his wife, Sophie, in Sarajevo triggers World War I 1914 — The Panama
Canal, under construction by the U.S. since 1906, is inaugurated 1915 — Einstein develops his General Theory of Relativity

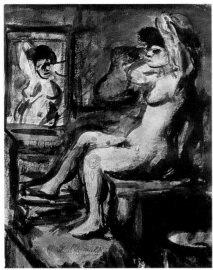

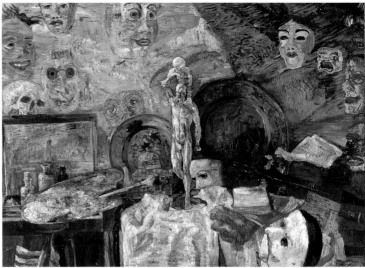

11

12

the admired model for Kokoschka and Schiele, whose personal Expressionistic idiom developed by way of Klimt's daring form and colour, which the more conservative wing of the Viennese Secession found subversive. Klimt also communicated an existential involvement with subjects such as sexuality, illness and death to the Expressionists. The influence of Sigmund Freud's psychoanalysis on the artistic environment of the day lent Austrian Expressionism its special note.

Countless components made the map of Expressionism into a many-coloured and complex tapestry. Accents were set by a series of lone wolves. For Kandinsky, Feininger, Dix and others, the style represented no more than a brief phase. Nor should we forget that expressionistic tendencies appeared beyond the borders of the German-speaking world as well. In Belgium, for example, the work of Constant Permeke (1886–1952), Gustaaf de Smet (1877–1943), Frits van den Berghe (1883–1939) and Albert Servaes (1883–1966) is spoken of as Flemish Expressionism. Two further painters also deserve mention.

One was Chaim Soutine (1893–1943), a Lithuanian Jew who worked from 1916 onwards in Paris. His friends, including Amedeo Modigliani (1884–1920), had connections with the Berlin journal *Der Sturm* and were familiar with publications on German Expressionism. Soon Soutine began to pursue aims that brought him into close proximity with the prewar work of Ludwig Meidner (fig. 9), a friend of Modigliani's. However, it is uncertain whether Soutine ever saw Ger-

man Expressionist art in the original. In France and the United States, where he was lauded – later, incidentally, by the Abstract Expressionists, above all Willem de Kooning (1904–1997), who admired Soutine's depictions of slaughtered cattle – Soutine was long believed to have influenced Oskar Kokoschka. This is incorrect for chronological reasons alone, and was always vehemently denied by Kokoschka himself. Nor can the occasional reversal of this relationship be proven.

The second artist in question, the Fauvist Georges Rouault (1871–1958), has likewise frequently been compared to Kokoschka in his Dresden period. The French artist outlined his figures with extremely heavy contours and filled the spaces with strong colours. In 1905, he began concentrating increasingly on religious subjects. In these respects Rouault's work came closer than that of any other French artist to German Expressionism (fig. 11), for instance the paintings of Nolde or Beckmann.

Citing names like Soutine, Rouault and others, occasional attempts have been made to define something in the nature of French Expressionism. In 1928, in fact, Galerie Alice Manteau in Paris mounted an exhibition titled "L'Expressionisme Français", at which works by Soutine, Modigliani, Vlaminck (1876–1958), Maurice Utrillo (1883–1955) and Marc Chagall (1887–1985) were shown under the premise that they all reflected a heightened awareness of an inner world and employed subjective means of depiction marked by energetic

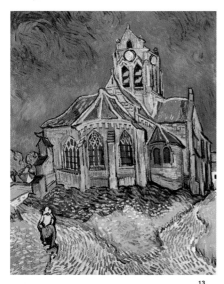

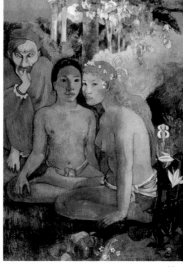

13) VINCENT VAN GOGH

<u>The Church of Auvers</u>
1890, Oil on canvas, 94 x 74 cm
Paris, Musée d'Orsay

14) PAUL GAUGUIN

<u>Contes barbares (Exotic Legends)</u>
1902, Oil on canvas, 131.5 x 90.5 cm
Essen, Museum Folkwang

13 14

gestures, distortions of form, and orgies of colour – criteria, in other words, that had long been canonized in Germany as those of Expressionism.

From the Reservoir of the European Avant-Garde

What was the art scene like when the Expressionists came on stage? As a point of departure, let us take prewar Berlin, where Die Brücke moved after their first years in Dresden. Wilhelm II, King of Prussia and Kaiser of the German Empire, felt duty-bound to set the tone in artistic matters as well as political, despite the fact that progressive minds thought he had the taste of "a cook or baker's boy". What this dilettante on the throne enjoyed were the pedantic, overloaded pomposities of Anton von Werner (1843–1915), his court artist. Anything that diverged from painstakingly rendered historical costume scenes or innocuous salon paintings was relegated to the category of "gutter art", from the socially committed prints of Käthe Kollwitz (1867–1945) and the earthy Impressionism of Max Liebermann (1847–1935) to the absolutely crazy Expressionists and, of course, every foreign so-called "avant-garde". Most of the revolutionary advances in modern art had long since taken place in Paris, and had been presented to the Berlin public by audacious art dealers,

journals and collectors. The Belgian James Ensor (1860–1949) and the Norwegian Edvard Munch, who was long active in Germany, likewise caused a sensation there.

The Expressionists in Berlin and elsewhere welcomed any brand of painting that was based without reserve on subjective experience and its radical translation into expressive forms and colour arrangements, and that accordingly overcame art's conventional function of representing or illustrating appearances. This held for Ensor (fig. 12), who revealed the depravity behind the masquerade of modern mass society and by so doing deeply impressed Nolde, for one. And this held even more for the symbolistic art of Munch with its expressive graphic abbreviations, which affected the art of Die Brücke especially. Munch's famous *Scream* of 1893 (fig. 10) projected all the torments of life into a child's face distorted into an emblematic, unforgettable grimace. Munch's inscription in the fiery red sky is indicative: "Could only have been painted by a madman."

And again and again, it was two "fathers of modernism" who cast their spell over the Expressionists: Vincent van Gogh (fig. 13) and Paul Gauguin (1848–1903; fig. 14), who shared what Uwe M. Schneede has described as "The 'rough image', whose distorted perspectives, flatness, deformations … run counter to all well-worn traditions … The 'rough image': made of coarsely rubbed pigment, on ever coarser canvas, in rapidly applied, broad brushstrokes, with parts of

1917 — Lenin and Trotsky lay the groundwork for the Communist Revolution in Russia 1918 — Following the November Revolution in Germany, Kaiser Wilhelm II is forced to abdicate

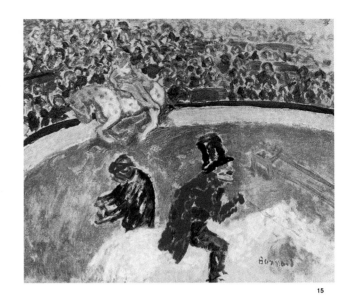

15) PIERRE BONNARD
<u>At the Circus</u>
c. 1900, Oil on canvas, 54 x 65 cm
Paris, private collection

the canvas left uncovered …, revealing the sequential character of the painting process …"

The first van Gogh exhibition in Germany, whose significance cannot be overstated, was mounted in 1905, the founding year of Die Brücke, at Galerie Arnold in Dresden. However, the same van Gogh touched off a notorious scandal in Germany. In 1911, when a van Gogh work was acquired by the Kunsthalle Bremen, the mediocre painter Carl Vinnen launched a petition protesting at what he termed "alien domination" of German art. The petition was signed by several renowned artists, strangely including Käthe Kollwitz. Marc and Kandinsky immediately organized a counterprotest, which was supported by museum directors, art historians and artists and appeared in print by the summer of that year with Piper, Munich, under the title *Im Kampf um die Kunst* (The Struggle for Art).

The exotic, if Europeanized, mythical aura of Gauguin's Tahitian paintings, on the other hand, struck the Expressionists as a perfect synthesis of life and art. They admired Gauguin's emotionally moving figures and were inspired by his generous, sweeping planes and his tendency to the daringly decorative – stylistic means, in other words, of the kind which were later adopted in Gauguin's wake by the Nabis.

In 1905, a band of young artists shocked Paris audiences. One critic called them "les Fauves", or "The Savages", Led by Henri Matisse (1869–1954; fig. 16), Georges Rouault, Maurice de Vlaminck and André Derain (1880–1954), they were joined the following year by Georges Braque (1882–1963) and Raoul Dufy (1877–1953). A movement that was as influential as it was short-lived, Fauvism might be briefly described as painting rich in colours deployed in luminous, flat planes in which figures and objects were abstracted and reduced to essentials. The colours were released from the task of naturalistic description, and were therefore capable of developing an enormous power of expression. At times, tense lines held the colour areas together, yet often these strokes took a loose, approximate course, not always forming definite contours and serving more to accentuate areas than to isolate them. The fascination exerted on the Fauves by sub-Saharan African and Oceanic art strengthened their resolve to engender decorative effects by means as simple as possible. If the rhythm of a composition made it necessary, they distorted forms or employed "unnatural" spatial relationships. Around 1908, Fauvist painting became widely known in Germany, through the mediation of Die Brücke and the Neue Künstlervereinigung, or New Artists Association, in Munich. Fauvism became an inexhaustible reservoir, from which other Expressionists soon began to draw as well.

The representatives of Der Blaue Reiter and Rhenish Expressionism tapped a different source: the Orphism of Robert Delaunay (1885–1941). The highly respected Delaunay began with Cubism, yet was disturbed by the studio still-life motifs on which Cubist

1918 — In Germany, the Communist Party ("Spartacus League") and the "Steel Helmet League" are founded. In 1933, the latter were absorbed into Hitler's SA "stormtroopers"

1918 — Czar Nicholas II and his family are shot by the Bolsheviks

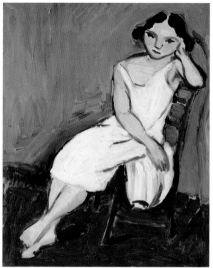

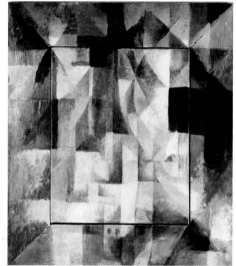

16 17

facetting of form was demonstrated. He was intrigued by the vitality and motion of the big city, the simultaneity of its phenomena, its electric lighting, and its new perspectives in time and space, which he transformed into a dynamic, increasingly abstract painting in exquisitely balanced colours (fig. 17).

The 1912 "Sonderbund" exhibition in Cologne, mentioned above, reflected the rich spectrum of influences that shaped the development of Expressionism. At its centre stood van Gogh, Munch, Cézanne and Gauguin. Picasso, important for the Expressionists working both in Berlin and Munich, was likewise well represented, as were the Cubists, Matisse and the Fauves. Kokoschka and Schiele were on view, and Expressionists from Die Brücke and Der Blaue Reiter. Munch described the exhibition in a letter of May 1912: "The wildest things being painted in Europe are gathered here …"

The chain of revolts – a review

On June 7, 1905, the students of architecture Fritz Bleyl (1880–1960) – who, however, was soon to turn his back on art – Ernst Ludwig Kirchner, Erich Heckel and Karl Schmidt-Rottluff formed in Dresden the artists' group Die Brücke (fig. 18). The name went back to a passage in Nietzsche's *Thus Spake Zarathustra* (1883–85):

"What is great in Man is that he is a bridge and not a goal; what is lovable in Man is that he is a passing over and a passing under …" The four viewed themselves as a chosen elite that set out to make "elbow room and free lives" for themselves "in face of the established, older forces," as stated in their founding manifesto. In 1906 Pechstein joined the group, as did Nolde, who, however, left it again only a year and a half later. Otto Mueller became a member in 1910.

The Brücke programme, published in 1906, was an appeal to all progressive makers of art to join forces and bring into being a revolutionary artistic existence. The appeal was too passionate to be satisfied with local effects, and was accordingly directed to artists outside Germany as well. It reached, for instance, Cuno Amiet (1868–1961) of Switzerland, who was very knowledgeable about the Parisian scene, and Axel Gallén-Kallela (1865–1931) of Finland. In 1908, the Dutchman Kees van Dongen (1877–1968), a Fauvist (fig. 19), joined as an honorary member for a good year. The ardently wooed Edvard Munch at least became a passive member, one of the friends and supporters of the group who wasted no time in becoming active – mounting seventy group exhibitions from 1905 to 1913, in Germany and abroad.

Break up encrusted structures – that was the warcry. When Kirchner and his friends painted from the model in group studio sessions they used to change places frequently. This spontaneous change of viewpoint and their rapid working speed facilitated an

1919 — Rosa Luxemburg and Karl Liebknecht, leading German left-wing socialists, are assassinated by a rightist officer
1919 — The "German Workers' Party", the germ of the Nazi Party, is founded: Adolf Hitler becomes its seventh member

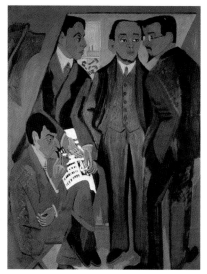

16) HENRI MATISSE
<u>Seated Girl</u>
1909, Oil on canvas, 41.5 x 33.5 cm
Cologne, Museum Ludwig

17) ROBERT DELAUNAY
<u>Window on the City</u>
1912, Oil on canvas, painted dead frame, 46 x 40 cm
Hamburg, Hamburger Kunsthalle

18) ERNST LUDWIG KIRCHNER
<u>A Group of Artists</u>
1926–27, Oil on canvas, 168 x 126 cm
Cologne, Museum Ludwig

18

almost automatic approach to drawing and a summary painting style, and schooled their eye for simplified, reduced form). Summers were spent at the Moritzburg Lakes outside Dresden, where the group envisaged a harmony of man and nature, a life free of the compulsions of civilization, or, as it were, a Gauguinesque Tahiti at their doorstep (fig. 8). Yet the Expressionist revolutionaries who tried to leave tradition behind still looked back in awe to the greats of art history, were susceptible as much to Post-Impressionist and Fauvist influences as to medieval woodcuts (fig. 25). It is surely no coincidence that the styles of the individual group members at this time are hardly distinguishable from one another. They were all fascinated by the art of the South Pacific and sub-Saharan African peoples, which they studied at the Dresden Museum of Ethnology. The black contours, angular figure types, masklike faces and vital poses of the figures in their paintings derived in part from this experience. Kirchner discovered in an English illustrated volume examples of ancient Indian painting and rapidly adapted them to his needs. The Gauguin exhibition at Galerie Arnold, Dresden, in 1910 provided a further impetus for the group's concern with the modes of perception and depiction of non-European cultures.

In 1911 the Brücke artists moved to Berlin. There Herwarth Walden had just opened his gallery, *Der Sturm,* and begun publishing the revolutionary journal of that name, one of whose editors was Kokoschka. Through *Der Sturm* the Brücke artists made contacts with literary Expressionism, and also with the radical anti-bourgeois circle around Franz Pfemfert and his journal *Die Aktion,* established in March 1911. These contacts resulted in a stronger orientation on the painters' part toward issues of content. A link between Kirchner and *Der Sturm* was forged by Alfred Döblin (1878–1957), a psychiatrist and writer whose big-city novel, *Berlin Alexanderplatz,* would make him famous in 1928. Such contacts facilitated the urge of Expressionist artists to transcend the limitations of art genres and become active in every field of creative work. An example was the forty-seven woodcut illustrations, endpapers, frontispiece and two-coloured woodcut Kirchner created for Georg Heym's volume of poetry, *Umbra vitae,* of 1924, one of the most cogent and significant works of Expressionist book illustration.

Although the Brücke initially remained together in Berlin, divergences in their previous collective style soon became apparent. Each artist began to react in a different way to the moloch of the big city, from which they occasionally, if no longer as a group, fled to various idyllic places: the Moritzburg Lakes, the village of Dangast on the North Sea, Nidden in East Prussia, or the Baltic island of Fehmarn. The differences within the group grew, until its final breakup was provoked by Kirchner, as Die Brücke informed its friends and supporters on May 27, 1913.

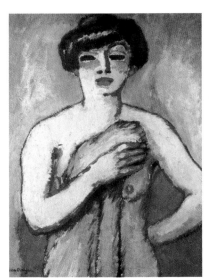

19

19) KEES VAN DONGEN
<u>Portrait of Fernande</u>
1906, Oil on canvas, 100 x 81 cm
Private collection

20) KARL SCHMIDT-ROTTLUFF
<u>Girl at her Toilette</u>
1912, Oil on canvas, 84.5 x 76 cm
Berlin, Brücke-Museum

21) EMIL NOLDE
<u>Prophet</u>
1912, Woodcut, 32.4 x 22 cm
Bernried, Buchheim Museum

"Munich was resplendent," declared Thomas Mann (1875–1955) in his 1902 story *Gladius Dei.* He probably meant this ironically, for around the turn of the century the Bavarian metropolis hosted not only relatively progressive, Art Nouveau-inspired tendencies but thoroughly commercialized conservative styles. Still, the art centre was resplendent enough to attract the genius of Kandinsky as the century got underway. Initially an adherent of Jugendstil, the German version of Art Nouveau, Kandinsky returned to his new home in 1906 from the Gauguin memorial exhibition in Paris with many new ideas. These he proceeded to combine with elements of Russian folk art, in which he naturally felt at home. Two years later Kandinsky and his pupil and long-time consort, Gabriele Münter, were working in Murnau, Upper Bavaria, studying the folk art of the Alpine foothill region, copying *verre églomisé*, and adapting this technique based on flat stylized forms, brilliant colours and strong black contours. And another year later, in 1909, the two artists established the Neue Künstlervereinigung München (NKVM, or New Artists Association of Munich). The other founding members were Alexei von Jawlensky (fig. 23), Marianne von Werefkin, Vladimir von Bechteyeff (1878–1971), the two future Neue Sachlichkeit artists Adolf Erbslöh (1881–1947) and Alexander Kanoldt (1881–1939), the significant Karl Hofer (1878–1955) – who would later, over his own protests, continually be reckoned an Expressionist – and finally, Alfred Kubin. Soon the group was joined by others, including art historians, dancers (Alexander Sacharoff – see p. 48), musicians and literary people. The NKVM, by the way, was the first artists' association to include large numbers of women, as members or guests, a circumstance that was largely the result of Werefkin's strong personality.

Kandinsky, the association's chairman, envisaged overcoming the self-satisfied art of the salons by aiming at a synthesis of all artistic ideals in the sublimating melting pot of the spiritual. Impulses from diverse quarters were welcome. This was illustrated particularly by the second association show at Galerie Thannhauser, Munich, in 1910, which included works by Picasso, Braque, Derain, van Dongen (fig. 19), Rouault (fig. 11), and the brothers David (1882–1967) and Vladimir Burlyuk (1886–1917). Erbslöh exemplified the international networking of the NKVM at the time, in the way in which he proceeded from Art Nouveau, Post-Impressionist and early Cubist influences to a reduced and concentrated imagery in highly luminous colours which could stand beside that of Fauvism. Yet Kandinsky, for his part, had already taken the next step. That same year he painted what he programmatically titled his "first abstract watercolour".

The press was shocked by the association's show. Franz Marc reacted with a positive review, and at the beginning of 1911 joined the NKVM. Yet that December, plans for a third exhibition led to controversy and a rupture. For spurious reasons the "moderate" faction

1922 — James Joyce publishes his novel ***Ulysses***; in Germany, Bertolt Brecht becomes known for his play ***Drums in the Night***
1922 — Howard Carter discovers the tomb of Egyptian pharaoh Tut-ench-Amun

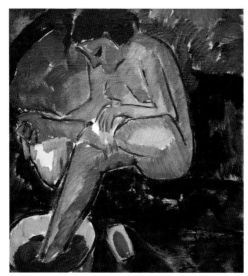

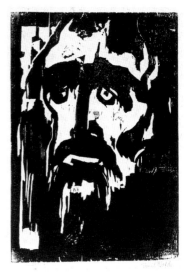

20

21

rejected a largely abstract painting by Kandinsky. In reaction, he and Münter, Marc and Kubin resigned from the NKVM and rapidly arranged a sort of rival exhibition, likewise held at Galerie Thannhauser: "Der Blaue Reiter", 1911–12, at which Macke, Campendonk, Delaunay, and the composer Arnold Schoenberg were also represented with pictures. Thereafter the works were on view in several other German cities, including Berlin, at the Sturm gallery. Walden additionally showed works by Paul Klee and the Russians Jawlensky and Werefkin (both of whom would leave the NKVM in 1912).

During these eventful years Kandinsky and Marc planned an almanach: *Der Blaue Reiter,* published in May 1912 by Reinhard Piper, which would not go beyond one edition. Kandinsky made ten different cover designs, most of them in watercolour (fig. 24). "Both of us loved blue, Marc horses, I riders. Hence the name," as Kandinsky would explain years later. Conceivably associations with the mysterious "blue flower" which the poet Novalis (1772–1801) had placed in the cradle of Romanticism also played some role here. Revealing for the interdisciplinary conception of the almanach were essays that represent some of the most crucial artists' statements of modernism. There was one by Marc, on "The 'Fauves' of Germany", and one by Burlyuk, on "The 'Fauves' of Russia". Macke wrote about "Masks", Kubin about "Free Music". Kandinsky contributed an essay "Concerning Stage Composition". Schoenberg wrote an article about music and its re-

lationship to words, and two of his paintings were reproduced in the almanach as well. Kandinsky in particular was deeply moved by Schoenberg's compositions and paintings, and saw his dual gift as confirming his, Kandinsky's, theory of the analogy between music and art. The "latest painterly movement," postulated Marc in the almanach, displayed "its fine connecting filaments with the Gothic and the primitives, with Africa and the great Orient, with that so strongly expressive, primal folk art and children's art".

Despite the unity displayed in their yearbook, the artists involved formed no coherent group along Brücke lines. The now-legendary "First Comprehensive Exhibition" of the Blauer Reiter at Galerie Hans Goltz, in February 1912, was not intended to manifest any common style, but to show, "through the *diversity* of the forms represented, how the *inmost desire* of artists takes manifold shape." And this was to be demonstrated on an international level, by the inclusion of pictures by Gauguin, van Gogh, Cézanne, Matisse, the "naive" painter Henri Rousseau (1844–1910), by Delaunay, Derain, Vlaminck, Picasso, Braque, by various Brücke artists (despite Kandinsky's serious misgivings), and furthermore, by the Russian avant-gardists Mikhail Larionov (1881–1964), Kasimir Malevich (1878–1935) and Natalia Goncharova (1881–1962).

In his essay "The New Painting", published in the journal *Pan* for March 1912, Marc demanded that the profound spiritual aspect of

1922 — Mussolini's March on Rome provokes a fascist coup in Italy 1923 — In Munich, the Hitler Putsch fails
1923 — In Germany, inflation reaches a peak when one dollar is equivalent to 4.2 trillion marks

19

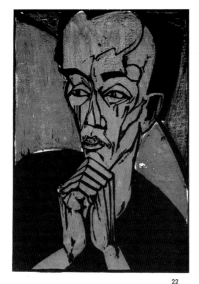

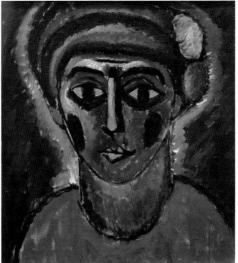

22 23

nature be liberated from the fetters of the visible in painting. Max Beckmann replied, in the next issue of *Pan,* that the crucial thing was "artistic perception, combined with artistic objectivity and truthfulness to the things to be depicted," and then went on to rail at "framed Gauguin wallpaper, Matisse-print cloth, little Picasso chessboards, and Siberian-Bavarian martyr posters." This controversy was symptomatic of the polarization of art between abstraction and figuration that now began and would flare up throughout the twentieth century.

Blue Rider exhibitions were on view from 1912 to 1914 in twelve cities, not only in Germany but also in Hungary, Norway, Finland and Sweden. The outbreak of the First World War put an abrupt end to these activities, which were such a crucial breakthrough for modernism. New hope followed the debacle when the German-American Lyonel Feininger, who had been affiliated with the Blauer Reiter since 1913, joined with Kandinsky, Klee and Jawlensky in 1924 to form Die Blaue Vier, or The Blue Four, a group that passed on ideas from the Munich period to the Bauhaus (fig. 25).

Oskar Kokoschka, of Vienna, was the first Expressionist to have drawings published in *Der Sturm.* Walden had brought him to Berlin in 1910, and until 1911 he remained a close collaborator of the journal, whose editing and illustrations crucially shaped its look. Thus Kokoschka embodied one of the many links that connected the various separate streams of Expressionism, although he basically belonged to its Austrian branch. His countryman Richard Gerstl (1883–1908) was a brillant, angry "young savage". In 1908 he took his own life at the age of twenty-five, not without previously burning his letters, notes and a good proportion of his works. The surviving paintings (fig. 26) reflect Gerstl's incomparably free and nervous handling of paint, and what might be called his "dematerialization" of figures. He, Kokoschka and Schiele stand for the decade in which Austrian art and its oppressive themes projected what Karl Kraus termed the "experimental setup for the end of the world". As art historian Uwe M. Schneede writes, "Schiele's daring torsions of the body and Kokoschka's unique series of revelatory portraits … clearly reflect the intensity with which they ascertained the relationships between body and soul, and how they attempted, under the influence of Sigmund Freud, to develop a pictorially effective body language, whose wide-ranging exaltations were moreover a reaction to the Viennese eurhythmic dance of the period." Kokoschka aimed at creating a "deranged portrait", as he himself wrote, and a contemporary man of letters, Albert Ehrenstein, credited him with being a "slitter-open of souls".

The intriguing Max Beckmann, the so different sculptors Wilhelm Lehmbruck and Ernst Barlach, the Worpswede/Paris painter Paula Modersohn-Becker, the prophet of doom Ludwig Meidner – all of these were loners, despite the fact that the latter founded a group in 1911. In a coachmen's pub in Berlin, a city Meidner called "the in-

1924 — After Lenin's death, Stalin wins the struggle for political leadership in Russia 1924 — First Winter Olympic Games take place in Chamonix, France
1926 — Sergei Eisenstein makes avant-garde film *Battleship Potemkin*

20

22) ERICH HECKEL

Male Portrait
1919, Color woodcut, 46.2 x 32.6 cm
Berlin, Brücke-Museum

23) ALEXEI VON JAWLENSKY

Head of an Adolescent Boy (known as Heracles)
1912, Oil on cardboard, 59 x 53.5 cm
Dortmund, Museum am Ostwall

24) WASSILY KANDINSKY

Cover for "Der Blaue Reiter" Almanach
1912, Color woodcut, 27.9 x 21.1 cm
Munich, Städtische Galerie im Lenbachhaus

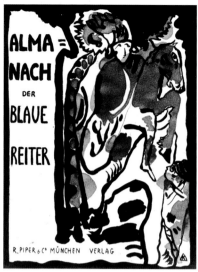

24

tellectual and moral capital of the world," he formed "The Patheticals", a short-lived group of Jewish artists who had their breakthrough at the Sturm gallery. Yet Meidner rejected Matisse, Kandinsky and Marc, just as he did the Brücke members who lived in his neighbourhood, who, he maintained, "favoured Negro art, which only drew attention away from contemporary subjects." While the "Pathetiker" Jakob Steinhardt (1887–1968), who would emigrate to Palestine in 1933, could doubtlessly be viewed, down into the 1920s, as an Expressionist with a stylistic and expressive affinity to Meidner, Dix and Grosz, many other artists lacked such similarities of style to the point that one wonders whether they can properly be associated with Expressionism at all. The same issue is raised, in part, even by sociocritically oriented artists like Käthe Kollwitz, who came from realism, or by the later Grosz and Dix, with their Dada or Neue Sachlichkeit tendencies. And it is an issue that becomes extremely controversial in face of the late work of someone like Lovis Corinth.

Film and Architecture

German Expressionist film focused the potentials offered by painting and other media by radically heightening both their form and content. This becomes apparent when we compare the sets of the 1919 film *The Cabinet of Dr. Caligari* (fig. 27) with a painting by Meidner (fig. 28), whose precipitous lines reveal Cubist and Futurist influences, among others. Responsible for the expressive decor was not the director, Robert Wiene, but the film designers (a task for which Alfred Kubin had originally been considered): the distorted perspective of diagonally converging lanes that intersect at acute angles; the cubic buildings seemingly on the verge of collapse; the light reflections from concealed streetlamps.

In many respects, the cinema drew inspiration from contemporaneous theatre productions. As early as 1906, for a scene in Ibsen's *Ghosts,* Max Reinhardt (1873–1943) had two actors rush past a bright lamp, casting enormous shadows on the back wall that gave the impression they were being pursued by demons.

Similiarly, in German films shadows were employed like omens of a fate from which there was no escape. In the famous film by Friedrich Wilhelm Murnau (1922), Nosferatu the vampire's, appearance is announced by his shadow ascending the stairs. German Expressionist films caused a sensation not least on account of their tense chiaroscuro, their harsh contrasts of light and dark, and their sharp illumination of a single figure or object while the surroundings remained plunged in gloom. This principle, which is so strongly reminiscent of Expressionist prints, came to a final culmination in Murnau's *Faust* film of 1926.

1926 — Physicist Erwin Schrödinger develops theory of quantum wave mechanics

1927 — In France, Marcel Proust's novel cycle *A la recherche du temps perdu* is published 1927 — Black dancer Josephine Baker celebrates triumphs in Paris

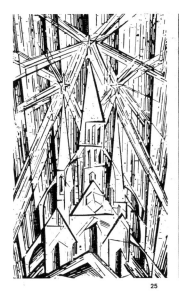

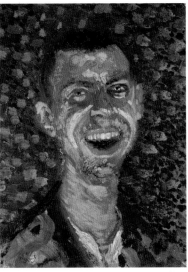

25 26

While the film explored life's abysmal depths, Expressionist architecture – a term whose use can be traced back to 1912/13 – emphasized its utopian aspect, which by definition could be put into practice only in plans and visions but not in reality. Crystal cathedrals and palaces grew into a paper sky. In many cases, this fictional architecture extended even to the design of earth and stars. An overcoming of matter and gravity through glass structures recalling Gothic cathedrals, a fascination with gigantic crystalline towers as symbols of purity, buildings overspanning the Alps, music of the spheres congealed into architecture, expressively splintered forms, even zoomorphic projects, all partook of a socialistic urge for world improvement. In late 1919, twelve architects joined with Bruno Taut (1880–1938) to form a correspondence group they dubbed "The Glass Chain".

In Germany, examples of built Expressionist architecture, naturally on a much less fantastic level, remained few and far between, such as Hans Poelzig's (1869–1936) Grosses Schauspielhaus in Berlin, 1918–19, and Erich Mendelsohn's (1887–1953) Einstein Tower in Potsdam, 1920–21. The architects of the Amsterdam School, in contrast, produced well-nigh uncountable numbers of buildings. "In Holland, Expressionism in architecture not only began earlier and had greater freedom than in Germany, it also lasted longer," as Wolfgang Pehnt notes. Noteworthy is the Amsterdam architects' group "Archi-

tectura et Amicitia", which appeared on the scene in 1915 and included Michel de Klerc (1884–1923) and Piet Kramer (1881–1961).

National Art or Morbid Mysticism? Things to Come

The "storms of steel" of the First World War did not give birth to the "New Man" so yearned for by Expressionism. Rather, a thoroughly beaten and despondent army trudged home to a republic shaken by hunger and inflation. *Didn't Christ Appear to You?* asked Schmidt-Rottluff in one of his woodcuts, in view of the dismal postwar situation.

Beckmann, Dix and Grosz (fig. 4) provokingly depicted the true face of its human wrecks, its disabled veterans and war profiteers, whores and new demagogues. Although the November Revolution breathed some final life into Expressionism, in what Ernst Bloch described as a combination of "Marxism and prayer", it seemed little more than a brief flicker. "Have the Expressionists fulfilled expectations for a new art that would brand the essence of life into our flesh? NO! NO! NO!" declared the "Dadaist Manifesto" of 1918, triggering a series of violent attacks on Expressionist attitudes by a younger generation of artists. "False and sentimental morbid mysticism", Beckmann called the movement in 1918.

1927 — Charles A. Lindbergh flies the North Atlantic alone, and immediately becomes an American national hero
1928 — Alexander Fleming discovers penicillin 1928 — Walt Disney creates first Mickey Mouse silent films

22

25) LYONEL FEININGER

<u>Cathedral of Socialism</u>
1919, Woodcut for the programme of the State
Bauhaus, 30.5 x 18.9 cm

26) RICHARD GERSTL

<u>Self-portrait, Laughing</u>
1908, Oil on canvas, 40 x 30 cm
Vienna, Österreichische Galerie Belvedere

27) ROBERT WIENE

<u>The Cabinet of Dr. Caligari</u>
1919, Film scene

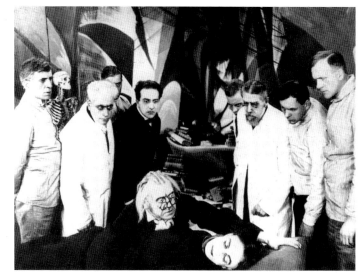

27

In the 1920s Dadaism was succeeded by Neue Sachlichkeit, a new art of sobriety or objectivity, and taking the tendency even further, a fanatical adherence to truth known as Verism, as exemplified by the development of Dix, Grosz, Karl Hubbuch (1891–1979), or Rudolf Schlichter (1890–1955). The perverted new *Pillars of Society* (thus the title of a 1926 painting by Grosz in the Nationalgalerie, Berlin), who inherited the prewar world seemingly unchanged, already began to flaunt an ominous new symbol: the swastika.

In 1918 the art historian Wilhelm Hausenstein proclaimed the death of Expressionism. His verdict was premature. After making their entry as a revolutionary force, in the Weimar Republic protagonists of Expressionism suddenly found themselves part of the artistic establishment. A case in point was Johannes Molzahn (1892–1965), who before emigrating to the United States had close ties with Bauhaus artists and, around 1919, had digested impulses from Delaunay to produce pictures reminiscent of Campendonk. In 1919 Molzahn published his "Manifesto of Absolute Expressionism", in which he proclaimed Expressionistic design principles as the basis of a strongly rhythmical Constructivism.

The ambivalence of Expressionism – an art that shocked the bourgeoisie versus an art that mystically celebrated the German soul – also divided the ideologues of incipient National Socialism. Speaking at the "Militant League for German Culture", founded in 1929, Al-fred Rosenberg listed its enemies, who apart from authors such as Bertolt Brecht, Thomas Mann and Kurt Tucholsky, included artists, mostly Expressionists, such as Beckmann, Kandinsky, Klee and Nolde, and even Hofer. In 1933, museum directors who toed the Nazi line began mounting exhibitions that pilloried "cultural Bolshevist", "degenerate" and "subversive" art, again for the most part Expressionist. In contrast, the "National Socialist German Students League", supported by Goebbels, credited Expressionism with possessing "true German character". This chauvinistic attempt at face-saving ultimately remained in vain. In 1937 it was primarily Expressionists who were demagogically humbled by the notorious Munich exhibition "Degenerate Art".

Even the German emigrés who hotly debated Expressionism in the Moscow exile journal *Das Wort* in 1937–38, were unable to agree whether it was revolutionary or reactionary. After 1945, Expressionism found its greatest echo outside Germany, in the United States. As a result, some of the most significant Expressionist pictures are now in U.S. museums and private collections. The earliest standard works on Expressionism were written by Americans. Many in the German art world were thunderstruck when Peter Selz, author of *German Expressionist Painting*, declared in 1957 that Expressionism was "one of the most central movements in the art of this century." And it was likely no coincidence that the first homegrown American "ism" received the ti-

1928 — Kurt Weill composes the *Threepenny Opera* in a jazz style, with lyrics provided by Bertolt Brecht

1929 — Plummeting prices on the New York Stock Exchange trigger a worldwide economic crisis

28) LUDWIG MEIDNER

<u>The Corner House (Villa Kochmann, Dresden)</u>
1913, Oil on canvas on cardboard, 92.7 x 78 cm
Madrid, Museo Thyssen-Bornemisza

29) HANS SCHAROUN

<u>Idea for a Community Centre</u>
1919, Watercolor on paper, 37.8 x 27.8 cm
Berlin, Akademie der Künste, Sammlung Baukunst

30) JACKSON POLLOCK

<u>Blue Poles</u>
1953, Oil, enamel and aluminium paint on canvas,
12,11 x 4,89 m
Canberra, Australian National Gallery

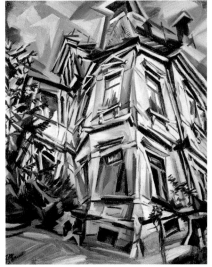 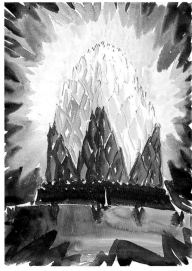

28 29

tle "Abstract Expressionism". Alfred H. Barr, director of the Museum of Modern Art, transferred a concept that had been applied to Kandinsky's abstract compositions to that painting of the 1940s and '50s which relied on direct, spontaneous action and emotional expression, as practised, to name only a few, by Willem de Kooning, Robert Motherwell (1915–1991) and Franz Kline (1910–1962), and which culminated in the Action Painting of Jackson Pollock (1912–1956; fig. 30).

Shortly after the war, the survivors of the German Expressionist generation – Schmidt-Rottluff, Pechstein, and Hofer (who must be named in this connection despite the fact that he was not a dyed-in-the-wool Expressionist) – established the Hochschule für Bildende Künste, or College of Visual Arts, in Berlin, whose later students would include Georg Baselitz (b. 1938), K.H. Hödicke (b. 1938) and Bernd Koberling (b. 1938). With them and other "young wild painters", figurative and/or symbolic Neo-Expressionism or Neo-Fauvism appeared on the scene in the 1970s and soon burgeoned into a key stream in contemporary art in Germany, but also in Italy, as exemplified by Enzo Cucchi (b. 1949). The radical gesture, to whose acceptance as a modernist device Expressionism contributed not a little, is as violent today as it ever was. It serves as an antidote whenever art threatens to grow too narcissistic and self-satisfied, and reminds us with a shock of the emotional basis of all good art.

1929 — The Geneva Convention, signed by forty-seven nations, requires humane treatment of war prisoners
1929 — The Museum of Modern Art, the most important of its kind in the world, is founded in New York

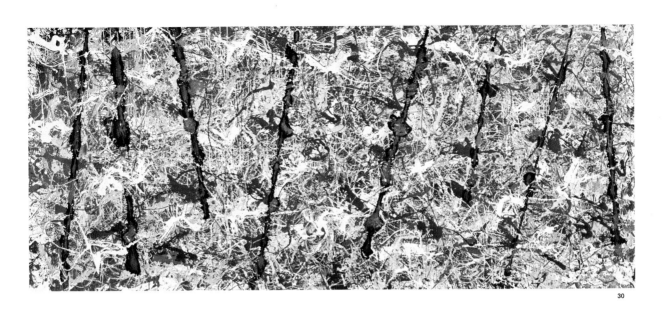

30

1930 — Based on a novel by Heinrich Mann, Joseph von Sternberg makes *The Blue Angel,* a sound film that catapults Marlene Dietrich to stardom
1930 — When his opponent, Jack Sharkey, is disqualified, Max Schmeling of Germany becomes the first non-American world boxing champion

The Refugee

Oak sculpture, 54 x 57 x 20.5 cm
Zurich, Kunsthaus Zürich

**b. 1870 in Wedel,
d. 1938 in Rostock**

More than those Brücke painters who occasionally created plastic works oriented to exotic and primitive art (fig. 6), Barlach can be considered an exponent of truly Expressionist sculpture. His central concern rapidly crystallized: to infuse figures composed of heavy, blocky forms with heightened psychological expression. This is perfectly evident in *The Refugee*, which seamlessly links up with Barlach's prewar work.

Here the human figure has been reduced to essentials, the contours and interior detailing being well-nigh abstract. And although conceived to be viewed from a certain vantage point, an ideal plane of relation, the plastic character of the volumes and the incredible way they take possession of the surrounding space are retained. The slight rising of the base to the right leads to the feature that ultimately lends the figure the appearance of a single sweeping movement: a diagonal cut into the wood, running from the bare foot on the left through the folds of the cloak which the refugee draws protectively around himself, then continuing abruptly to the upper right, where the cloak opens into an oval to reveal his hands and face. The striking head is not beautiful in the sense of earlier or academic ideals in art, but has coarse, ugly features that vaguely recall the appearance of Käthe Kollwitz. The gaze, suffering and anticipating worse things to come, is directed into the distance. The painfully visionary nature of this gaze and the face protruding beyond the contours of the wooden block anticipates the uncertain future, while the gently curving contour of the back seems to turn away from everything the anonymous refugee has left behind. The human figure reduced to essentials, as always with Barlach, becomes a symbol of a state, a supraindividual, archetypal situation.

The limited range of well-nigh crude formal means with which Barlach achieved an unprecedented expressiveness and suffused inert matter with spirit resulted not least from an encounter with late-Gothic graphic art and sculpture. Barlach, who was also a significant printmaker and one of the most important playwrights of Expressionism, settled in 1910 in the medieval town of Güstrow on the Baltic coast. At the cathedral there he was continually confronted with statues of the apostles created by Claus Berg (died between 1532 and 1535) – highly dramatic, plastically modelled and yet drawn out into the plane, their coarse-grained, greyish-yellow oak contributing to the both expressive and ascetic impression of the figures. These works etched themselves in Barlach's mind, and his affinity with them is manifested in only a slightly more modern, somewhat abstracted form in *The Refugee*.

After the First World War, Barlach declined offers to teach at the academies in Dresden and Berlin. Long before his success reached its apex in the 1930s, Nazi art critics had set their sights on him. On January 30, 1933, in protest at the forced resignation of Käthe Kollwitz and Heinrich Mann from the Prussian Academy of Arts, Barlach gave a radio talk titled "Artists of the Time". His monuments and public sculptures were destroyed.

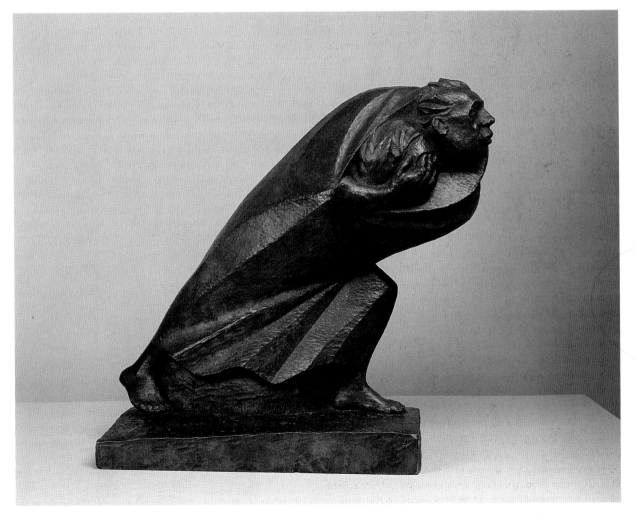

scene from the "Earthquake in Messina"

Oil on canvas, 253.5 x 262 cm
St. Louis, Saint Louis Art Museum, Bequest of Morton D. May

b. 1884 in Leipzig,
d. 1950 in New York

Beckmann played a role in twentieth-century art that overshadowed many others. His oeuvre rises like an erratic boulder in the landscape of German art. Yet certain points of contact with Expressionism can be discerned. After finishing his art studies in Weimar in 1903, he made trips to Paris – where he was impressed by the cruel medieval *Pietà* by the Master of Avignon, by Eugène Delacroix (1798–1863) and Paul Cézanne – and to Florence. From 1907 onwards his enormous canvases, alongside Corinth's paintings, were among the annual sensations at the Secession exhibitions in Berlin. These included a *Crucifixion,* a vision of the *Resurrection,* scenes of rapine and slaughter, and even *The Sinking of the Titanic* (1912). The age feverishly doted on just such sensations.

Beckmann began this *Scene from the Earthquake in Messina* on December 31, 1908, after reading a news report on the earthquake in southern Italy in which about 80,000 of the 120,000 inhabitants of Messina died. In his diary he noted: "Then I read more in the newspapers about the terrible disaster in Messina, and the passage where half-naked released prison inmates attack other people during the frightful confusion … gave me the idea for a new picture." The painting, in which Beckmann attempted to capture "all pulsating fleshly life", was likely finished in April 1909. The critics of the day found fault with its caricatural exaggeration and sensationalism, only one praising its pathos, which can be traced back to Delacroix.

The varied treatment of the figures gathered into small groups forms the underlying chord of the composition in dull earth colours. The eye is led into the picture by the half-undressed, crouching man in the right foreground, who, seriously wounded in the forehead, bears the pain with waning powers. The naked woman next to him rises up as if trying to avert her fate. The kneeling man behind her likewise seems struggling to maintain his composure. Placed in parallel to this trio of figures, on a rising diagonal, are groups of two figures each – beginning on the left with a rape scene – who are involved in a struggle to the death. Man, the artist seems to say, is simultaneously perpetrator and victim. The relatively intact buildings at the upper edge have the effect of an impenetrable barricade in front of which the battle for survival is taking place.

The young Beckmann was impressed by the vitalism of Nietzsche. This may explain why, apart from the themes of threat, fear and violence that can be seen as a metaphor for the brutality of the modern age, such paintings contain an undertone of fascination with crime, with an unleashing of archetypal instincts of cruelty.

Though artistically not entirely mature, the painting clearly indicates the way in which Beckmann's early work developed out of a sombre, Old Masterly naturalism with scattered Post-Impressionist accents towards an Expressionism whose fundamental feeling and harsh dissonances of content lent it a sense of violence. As the artist confessed, "I would pick my way through all the sewers of the world, through all its debasements and desecrations, in order to paint. I simply have to. Everything in me in the way of formal imagination must come out, down to the last drop …" This was the radical impulse behind Beckmann's decision to volunteer for the medical corps and go to the front. There, in summer 1915, he suffered a physical and mental breakdown.

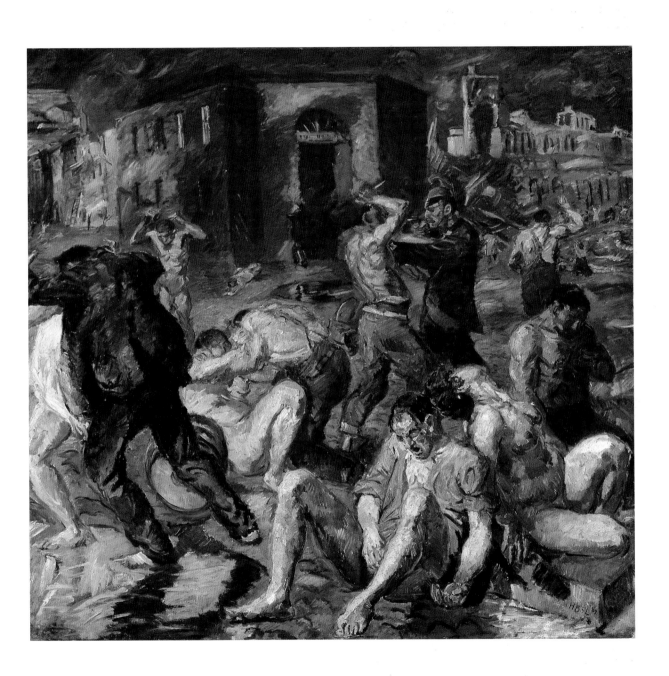

тhe Night

Oil on canvas, 133 x 154 cm
Düsseldorf, Kunstsammlung Nordrhein-Westfalen

His experiences in the First World War, which, as he euphorical-ly wrote to his wife in April 1915, provided "fodder" for his art, soon brought Beckmann to the brink of mental collapse. They also altered his art fundamentally, in both formal and iconographic terms. The paint application grew thinner and more fluid, figures and faces became more "linear" and took on ecstatically distorted poses and features. It was no coincidence that Beckmann created the greater part of his graphic oevre between 1915 and 1922. Yet everything done in those years was outshone by this large-format oil finished in 1919, *Night*, in which the world has gone out of joint.

After the outbreak of the November Revolution in 1918, vio-lence and chaos reigned in Germany, and political assassination was the order of the day. Beckmann's painting, too, rips the thin veneer off the aspect of bourgeois civilization. We look into a small, Gothically angled attic room, the perspective lines of whose floorboards turn it into a narrow stage teeming with actors. Three thugs have broken in and are routinely and sadistically raping and murdering the inhabi-tants, one grabbing a girl as if about to throw her out of the skewed open window. The torso and leg position of the strangled man, whose arm is being twisted by a pipe-smoking "technocrat of violence", re-calls the figure of Christ in a Deposition, his cruelly twisted foot per-haps stemming from Grünewald's *Christ Crucified* in his late-Gothic Isenheim Altarpiece (fig. 1). The thug at the right in the peaked cap is a paraphrase on a beggar from the fresco *The Triumph of Death* at the Campo Santo in Pisa, from the first half of the fourteenth century. The legs of the female figure who is the true centre of the drama, violently forced apart, serve in formal terms to link the two halves of the composition.

Despite its implicit story, the painting runs counter to every law of logic, a strange, crystalline petrifaction having taken possession of the events and figures. The howling dog remains just as silent as the gramophone; the toppled candle signifies death. Though it would seem plausible to detect references to current events here, for exam-ple to the crushing of the Spartacus revolt and the assassination of

Karl Liebknecht and Rosa Luxemburg in January 1919, the ambigu-ous and enigmatic nature of the image remain predominant. In Beck-mann's own words, "In my *Night*, too, one should not overlook the metaphysical in the objective." Metaphysics, to again cite the artist, meant "giving human beings an image of their destiny".

In artistic terms, metaphysics implied transforming figures into prototypes and stylizing the pictorial space, making it into a conglom-erate or complex network of "Cubo-Futurist" faceted planes and sharp-angled contrasts (which bore parallels with Expressionist film sets; fig. 27), and it implied replacing naturalistic depiction by an alienating distortion.

This key work and masterpiece of German painting between the wars already contains the most important elements with whose aid Beckmann would later find his genuine style, in exile in Amster-dam until 1947, then as an emigré in the United States. The linear, faceted forms would be increasingly abandoned in favour of brilliant expanses of colour and broad, black contours. This amounted to Beckmann's farewell to Expressionism, which he now rejected as be-ing "sentimental morbid mysticism".

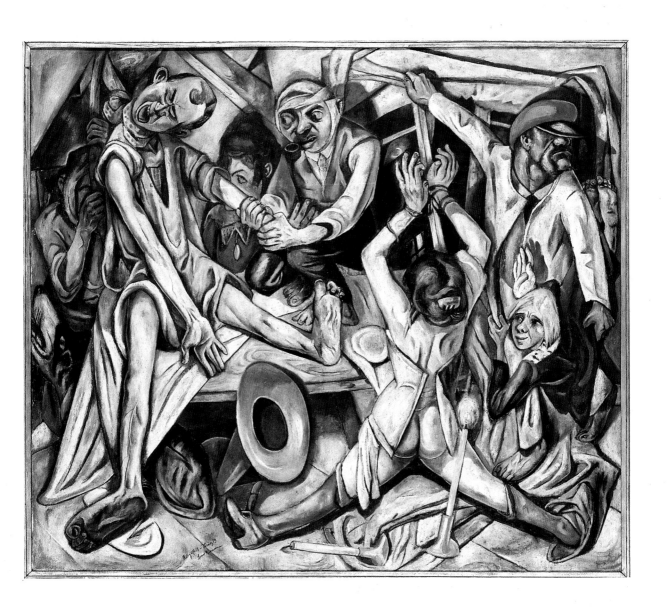

Bucolic Landscape

Oil on canvas, 100 x 85.5 cm
St. Louis, Saint Louis Art Museum, Bequest of Morton D. May

b. 1889 in Krefeld,
d. 1957 in Amsterdam

Campendonk's *Bucolic Landscape,* whose title suggests a kind of earthly paradise out of Antique mythology, is recognizable as such only on closer scrutiny. On first sight the vertical format has the effect of a stage, filled to bursting with forms, as if in reaction to a *horror vacui.* Yet the geometrically reduced, splintered, occasionally nearly abstract shapes of plants, human beings, animals overlapping one another ultimately produce not an effect of chaos but of a solidly built pictorial structure. The many and various tense oppositions and complementary colour contrasts are brought into an order that is calculated down to the last detail. Partially modelled elements with suggestions of spatial depth are always integrated in the dominant flat pattern. Features of the coloration and the important role played by animals in the scene may bring Franz Marc to mind; other features recall the lyrical, fairy-tale mood of Upper Bavarian *verre églomisé.* The facetted interpenetration of figures, animals and landscape, the constructive employment of form, colour and light, clearly echo Delaunay's principles of design.

Like his close friend Macke, Campendonk – born in Krefeld and active mainly there and, later, in Düsseldorf – is often associated with the theoretical construct of Rhenish Expressionism. Yet the years that were decisive to his artistic development in terms of style and thematic reorientation were those he spent under the influence of the Blauer Reiter artists in Munich, 1911–14.

From 1905 to 1909 Campendonk was a student at the Krefeld School of Decorative Arts. His teacher there, the Dutchman Jan Thorn-Prikker (1868–1932), introduced him not only to the stylization of Art Nouveau but to the art of Cézanne and van Gogh, and their reliance on the autonomous expressiveness of line and strongly contrasting colours. From 1911, when Campendonk moved to Sindelsdorf in Upper Bavaria and got to know Macke and Marc, he came increasingly under the latter's influence. So avidly did he adopt Marc's Cubist, crystalline compositions shot through with Futurist vectors and Delaunay's Orphist coloration that critical voices complained of Campendonk's lack of originality.

Yet gradually the differences between his more lyrically tuned temperament and Marc's mystical pantheism came to the fore. Though Marc's animal realm continued to fascinate him, Campendonk began to integrate glimpses of the everyday farm life around him into the fairy-tale, almost Romantic atmosphere of his compositions with their free-floating motifs. This approach, which would mature into his personal style, did not find its culmination until the last Munich years of 1913 and 1914, and finally after the dissolution of the Blauer Reiter. In the meantime Campendonk had further reduced his visual idiom to complex and solid geometric terms, a development manifested in *Bucolic Landscape.*

During the First World War, Campendonk was soon discharged from the military and retired to Seeshaupt on Lake Starnberg. In 1926, living in Krefeld, he accepted the offer of a teaching post at the Düsseldorf Academy. His later oeuvre included significant glass paintings. In 1933, Campendonk emigrated to Belgium, later going on to Amsterdam.

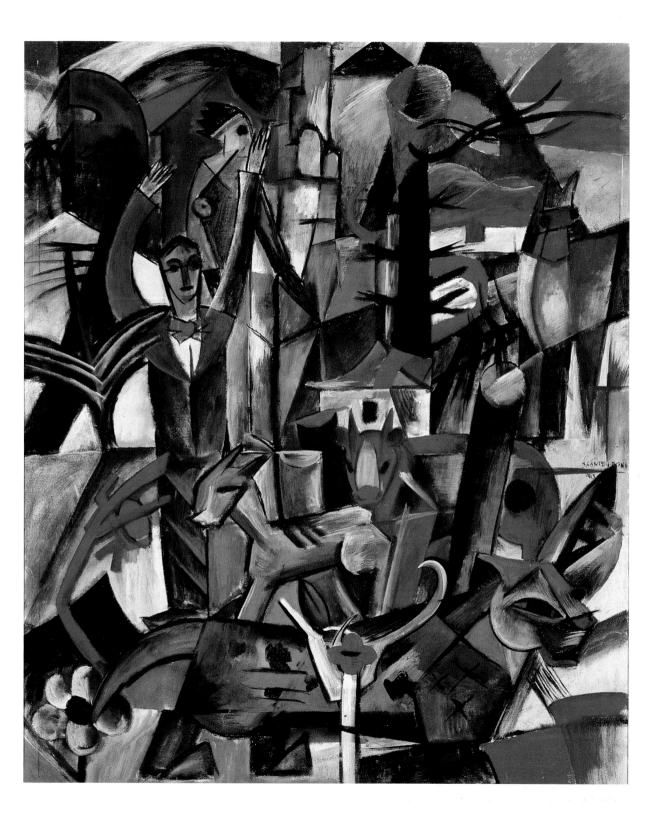

The Red Christ

Oil on wood, 129 x 108 cm
Munich, Pinakothek der Moderne – Staatsgalerie Moderner Kunst

**b. 1858 in Tapiau (now Gvardejsk),
d. 1925 in Zandvoort**

Lovis Corinth's depiction of the Crucifixion is doubtless one of the most moving in all modern art. In accordance with the predominant colour and its symbolism of blood, it bears the indicative title *The Red Christ*. Finished in 1922, the painting immediately caused a scandal when it was exhibited. One critic stated, "But this is not Christ at all, this is more like an apeman with a black woolly beard, protruding crude mouth area (or put less technically, snout), flattened pug nose, huge orbital bulges and devious black eyes. The body lacerated, tortured, blood and more blood wherever the eye turns. The sun, too, is bloody, and its rays look bloody. The picture is one single orgy of bloodlust."

The composition, which brings the motif up to the viewer's eyes like a cinematic close-up, is a combination of various elements from Cornith's earlier Crucifixion scenes. Yet it alienates, abstracts and distorts the details and divorces colour partially from objective representation, such that its impasto substance seems to take on a life of its own and cover the picture field as if with blood spatters. The heavenly cosmos sheds garish accents on the brutality of the nearly faceless henchmen in the foreground and the helplessness of Mary and St. John the Evangelist in the background. The paint surface is ploughed by vehement brushstrokes and swaths of the palette-knife. The figure of Christ, victim of murderous bestiality and reduced to a slaughtered creature, takes on exemplary meaning for the increasing loss of human dignity. The Crucifixion serves as a paradigm for the statement that man has become a wolf to man.

To this day art historians continue to have their difficulties with Corinth, especially with his work after 1911. He is very difficult to categorize. During an extremely long training period, at the academies in Königsberg, Munich and Paris, he was impressed primarily by various realistic styles – and even more by the art of Rembrandt (1606–1669). From 1891, when he resided in Munich, and after 1900, when he moved to Berlin, Corinth pulled out virtually all the stops of a theatrical, illusionistic painting located midway between naturalism and Impressionism. His aptitudes seemed anything but avant-garde.

At the apex of his career, in 1911, Corinth suffered a stroke. From then on he had to cope with extreme pressures, was tormented by deep bouts of depression, but also went through happy phases of a creative intoxication, as his famous Walchensee landscapes, among other works, attest. His approach turned radical, broke with academic conventions, unsettled visual habits. As Corinth himself once wrote, "Bad drawing and missing the mark are excused as soon as appearances are captured in their character." Most justice can be done to the artist's late style by considering it a sort of parallel phenomenon to Expressionism, even though Corinth never maintained contacts either with members of the Brücke or the Blauer Reiter. Yet at any rate, on the occasion of the 22nd Berlin Secession Exhibition in 1911, he did describe paintings by French Cubists and Fauvists as expressionistic, and recommended them to the public as highly interesting, precisely on account of their "wildness".

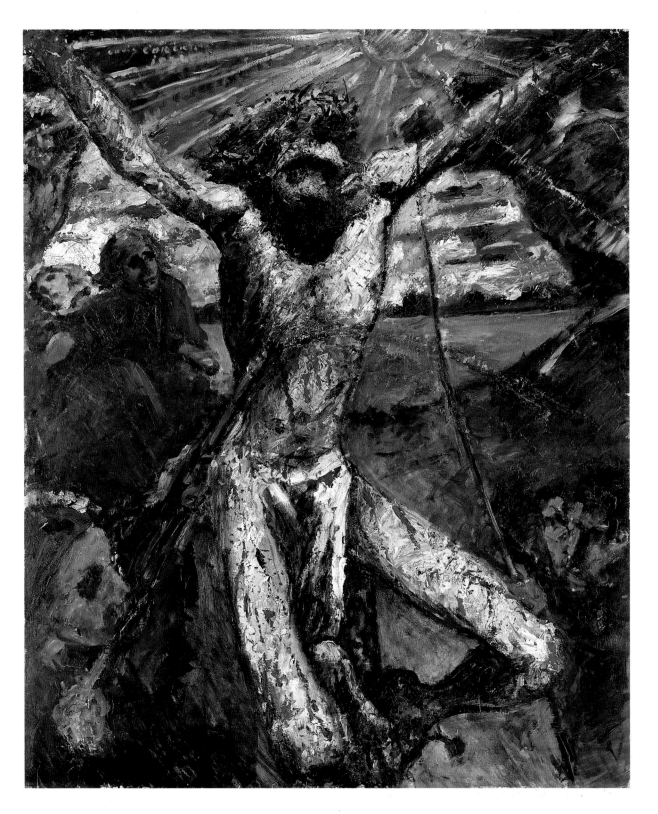

self-portrait as a soldier

Oil on paper, 68 x 53.5 cm
Stuttgart, Galerie der Stadt Stuttgart

**b. 1891 in Untermhaus (near Gera),
d. 1969 in Singen**

War was the first domi-
nant theme in the work of Otto
Dix after his training at the Dres-
den School of Decorative Arts. In
1915 he was sent to the West-
ern Front in Champagne, France,
went through the terrible autumn
battle and the trench warfare
that succeeded it that winter, in
which nearly 600,000 men lost
their lives. In November he was
promoted to non-commissioned
officer, received the Iron Cross
2nd Class, fought in the battles
on the Somme, which cost 470,000 lives, then participated in trench
warfare in northern France. In November 1917 Dix lay in the Russian
trenches and in February 1918 was stationed in Flanders. In August
of that year he was wounded in the neck, yet shortly thereafter took
pilot training. Dix was discharged in December. He had survived. "The
war was a horrible thing," he later wrote, "but something enormous
nevertheless. I wouldn't have missed it at any cost. You have to have
seen men in this unleashed state to know something about human
beings … I had to experience the worst aspects of life myself – that's
why I went into the war, and also why I volunteered."

There is hardly another work that illustrates this existential
premise better than Dix's *Self-Portrait as a Soldier*. The artist depicts
himself in close-up, presents his physique with an immediacy that al-
most seems to explode the small format. From the diagonally rotated
torso the head, in aggressive red, protrudes like a battering ram and
turns to fix the viewer with a provoking stare – and the viewer was of
course originally the artist himself, looking at himself in the mirror to
study his own physiognomy. The brutal, bald soldier with bony skull,
bull neck and fleshy mouth recalls a wounded wild animal at bay. En-
ergetic brushstrokes in blue, red and yellow-orange plough the sur-

face around the face, a formal equivalent for mental torment yet also
for a keen expectation of the "enormous" things awaiting the soldier.
Human life is first and foremost a struggle for life, and death is an in-
evitable part of its fascination – this Dix could have read in Nietzsche.
Like Beckmann, he took the Bible and Nietzsche's *Gay Science* along
with him to the front.

During intervals in the fighting, Dix amazingly executed almost
600 drawings and gouaches between 1915 and 1918. These com-
prise his actual Expressionist oeuvre. Nearly all of them are covered
with a network of intersecting, agitated lines interlocking at sharp an-
gles, vectors of force that combine into an ecstatic rhythm. The
colours often strangely recall the hovering notes of the Blauer Reiter,
oddly ethereal in view of the dissonant overall structures out of which
Cubo-Futuristic, expressively delineated and distorted objects and
landscapes emerge. Simultaneity congeals into a "creative chaos" that
is a far cry from a depiction of visible reality. Only long after the war's
end did Dix begin to capture his experiences in a more realistic man-
ner. In 1923–24 he produced a cycle of fifty etchings entitled *The
War,* a twentieth-century counterpart to Goya's (1746–1828) *Disas-
ters of War* (1810–1820) and almost certainly inspired by them.

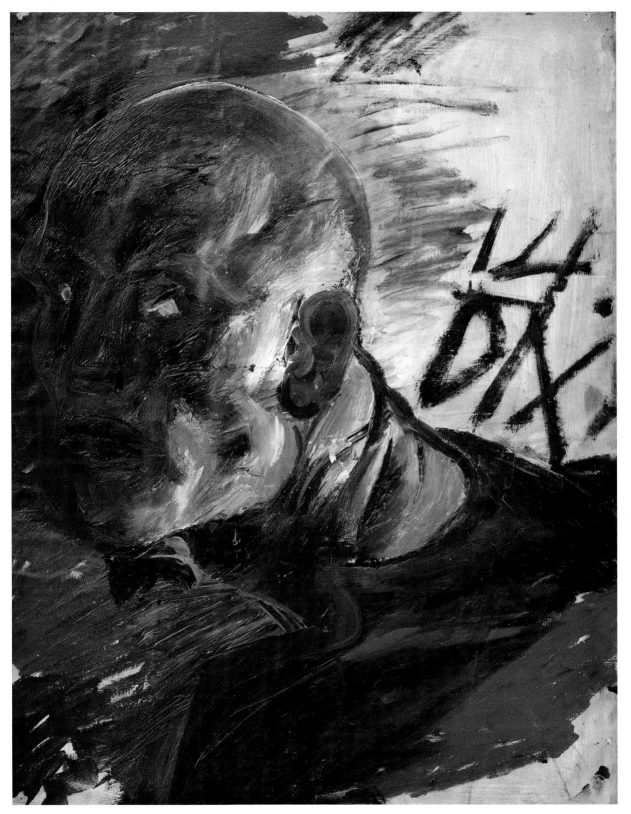

prager strasse

Oil on canvas with collage elements, 101 x 81 cm
Stuttgart, Galerie der Stadt Stuttgart

The Dix who returned to Dresden in 1919 – now as a master student at the Art Academy – probed new ways to react to a society whose brutality and hypocrisy had become evident in the trenches of the First World War. His Expressionist vocabulary was first supplemented by the montage principle of Dada and its method of sarcastic, shocking provocation, before Verism with its hyperreal attention to detail completely replaced the revolutionary formal pathos of Expressionism in Dix's art.

Yet even after the war, life manifested itself in terms of extremes in the artist's eye. He was intrigued by outsiders, including intellectuals and artist colleagues, but above all it was working people, prostitutes and disabled war veterans who now populated Dix's paintings and prints. He focused mercilessly on the transitory nature of the human body, and created icons of sexual ugliness. The factors of exaggeration, distortion and grotesqueness so important to Expressionism were retained, in one form or another, in Dix's postwar work. His earlier main themes – war and the big city – likewise played a key role in the artist's continuing mergers of disparate elements into a "creative chaos".

Prager Strasse, from which this oil painting with collage takes its title, was Dresden's most opulent street. In Dix's starkly Dadaist scene, it metamorphoses into a boulevard of disillusionment. The canvas with its inscription "Dedicated to my contemporaries" centres on bizarrely alienated war veterans, two of the many at that time whose disablement left them no alternative but begging to survive. The wheels of the cart on which the legless man pushes his torso along the pavement are formed of tinfoil. The photos, paper, hair and tickets in the upper part of the macabre shop window displaying disjointed stereotype body parts – torsos, limbs – are likewise pasted on. Between the light-coloured prostheses in the right-hand window Dix has inserted a photo of his own face. The newspaper clipping in the lower left corner – the compositional extension of a barking dachshund's mouth – is another authentic piece of reality that reflects the growing anti-Semitism of the postwar years: "Jews Out!" screams the headline.

Unlike the Zurich Dadaists who had come together in Swiss exile in 1916, the Berlin Dadaists had a clear and definitely left-leaning political attitude, whose message they focused in imagery composed of actual slices of the reality around them. This collage device was supplemented by unreal, overlapping perspectives, disintegrated formal structures, garish colours, and an aesthetic of the ugly – formal principles, that is, of typically Expressionist origin. With the aid of this art of combinations Dix shed a glaring light in *Prager Strasse* on the social injustices that characterized the young Weimar Republic, and he drew attention to the political perversions that would soon become embodied in tyranny.

When Hitler saw paintings by Dix in Dresden in 1937, he declared, "It's a shame one cannot put these people behind bars." By this time Dix had long turned away from Expressionism, having in the 1920s adopted the sharp-focus objectivity of Neue Sachlichkeit and especially Verism.

market church in нalle

Oil on canvas, 102 x 80.4 cm
Munich, Pinakothek der Moderne – Staatsgalerie Moderner Kunst

b. 1871 in New York,
d. 1956 in New York

Feininger's work is almost more difficult to categorize than Klee's. The American-born graphic artist and painter, who was also a talented musician and composer, was associated with various of the German Expressionist groups without truly belonging to them. In 1912 he maintained friendly relations with the Brücke, especially Heckel and Schmidt-Rottluff, in Berlin, and the following year exhibited with the Blauer Reiter in the "First German Autumn Salon". He arrived at his typical style in 1911, in Paris, by way of a confrontation with Cubism. With its aid Feininger translated his favourite motifs – Gothic church spires, cityscapes, seascapes, sailing ships – into compositions of crystalline purity and timelessness that anticipated the Expressionist architectural fantasies of the Glass Chain (see p. 22). This is the context in which his woodcut for the founding manifesto of the Bauhaus, *Cathedral of Socialism,* belongs (fig. 25).

Until 1913 many of his pictures were populated by marionette-like, elongated human figures which were subsequently abandoned. Feininger employed an exaggerated perspective to engender a pictorial tectonics consisting of a synthesis of cubic, prismatically refracted, energy-charged units. His early *Promenades* were probably known to Kirchner, who may well have adapted them in his *Potsdamer Platz* (ill. p. 57). On the other hand, Feininger paid homage to Kirchner's paintings of Berlin cocottes in his *Birds of the Night,* 1921.

As *Market Church in Halle* shows, by this time Feininger's facetting had achieved a rigorous tectonics and intrinsic monumentality. Between 1929 and 1931, on the invitation of museum director Alois W. Schardt, the artist spent several periods of months at a time in Halle to paint a series of city views. Like other examples from this series, the Munich painting has a subtle transparency of colour that reflects not only an adoption of the Orphist colour system of Delaunay but an affinity with international Constructivism, which paralleled Feininger's teaching activity at the Bauhaus, first in Weimar from 1919 to 1925, later in Dessau to 1932. At the Bauhaus, the rational, constructive principle was allied with Expressionist ideals à la Blauer Reiter. As a result, Feininger joined with Jawlensky, Kandinsky and Klee in 1924 to form a successor to the Munich group, The Blue Four.

Feininger has depicted the Market Church in Halle from a vantage point that relegates its characteristic spired facade and flying buttresses to the background, and brings the massive late-Gothic nave diagonally into the foreground and to the left edge, like a conglomerate of vectors and dynamic prisms. The complex is rendered in subdued translucent colours of luminous clarity, forming a Cubistically reduced structure shot through with lines, rays and facets. In the refractions and vibrations, interpenetrations, overlappings and mirrorings of forms, the synaesthesia of painting, architecture and music has achieved an overwhelming polyphonic effect, as of light-pervaded space. "Where I used to strive for movement and restlessness," said the artist, who emigrated to the U. S. in 1936, of such pictures, "I now attempt to sense and express the complete total calm of objects, and even the surrounding air. 'The world' that has moved farthest from reality."

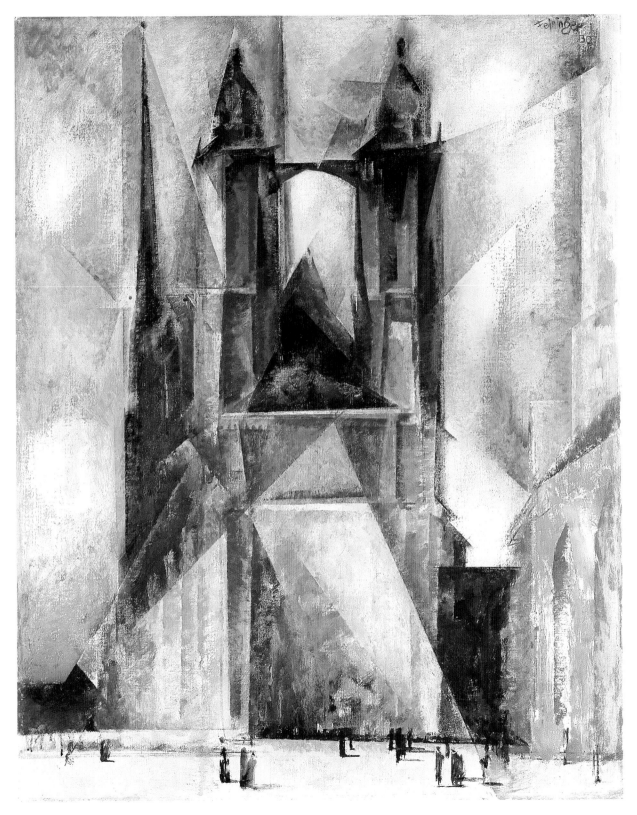

Dedicated to Oskar Panizza

Oil on canvas, 140 x 110 cm
Stuttgart, Staatsgalerie Stuttgart

b. 1893 in Berlin, d. 1959 in Berlin

Even more than his future friend, Otto Dix, George Grosz turned his art to political ends – although not in the sense of support for any party line, including that of the Communists, whom he joined in 1918. During his studies at the Dresden Academy from 1909 onwards, he followed the activities of the Brücke with interest, and soon those of the Blauer Reiter as well. Like every young artist in Germany who allied himself with the avant-garde, Grosz was familiar with progressive international developments in art. In November 1914 he hesitantly registered for war service, but by the time six months had passed, he had become unfit for duty. These six months fuelled Grosz's hatred of war and the military, to which a disgust with war profiteers was soon added. In January 1917 he was reinducted, but only a day later he had to be sent to an infirmary, and a few weeks afterwards was admitted to a mental hospital. During the war years Grosz concerned himself with the subjects of circus and variety shows, crime and murder, war and the big city. The last-named would become a synonym for a world gone out of joint for him.

One of Grosz's most striking works on this theme is *Dedicated to Oskar Panizza*. The aggressiveness of the painting inheres not only in the motifs but in the incandescent reds of the palette and the violent energies that stream through the composition. Even the solid architecture is infused with a compelling dynamism. It recalls the vertiginous spaces and toppling housefronts in the sets of Expressionist films (see p. 21). The seemingly endless street is filled with a milling crowd of Cubistically simplified figures who intersect and overlap one another. In the tumult of pushing, jostling people with masklike faces, everyone seems to have lost all sense of direction.

Grosz mixes Futurism and Cubism with a shot of James Ensor to form an overwrought boiling human mass that occupies the borderline between Dadaism and Expressionism. This big-city scene was intended as a homage to Oskar Panizza (1853–1921), an Expressionist writer and physician whose satirical attacks on Church and State appealed to Grosz. A short time earlier, the Italian Futurist Carlo Carrà (1881–1966) had depicted a similarly "political" funeral which ended in a bloody fight. But Grosz's wildly gesticulating mob milling around the coffin on which a schnapps-drinking Death is perched, not only served him as an excuse to evoke urban chaos. He also pointed out its source, in an urban jungle where a tiny church is completely engulfed by nightclubs and bars and office buildings. A highly decorated old army officer brandishes his sword as a moon-faced clergyman pathetically holds the cross on high and a sheep-faced office employee, on the left, demonstrates the herd instinct. The neon sign over the building entrance next to the coffin, "DANCING TONIGHT", says it all – this is a modern Dance of Death. As Grosz himself explained, "In a strange street by night, a hellish procession of dehumanized figures mills, their faces reflecting alcohol, syphilis, plague … I painted this protest against a humanity that had gone insane."

In his later work Grosz proceeded from Dadaism to the sober realism of Neue Sachlichkeit and a sociocritical Verism, jettisoning Expressionist formulae but retaining their satirical and critical impact. So it was no accident that a "humanity gone insane" soon caught up with him – in 1933 Grosz became one of the first victims of Nazi persecution in the arts. He emigrated to the United States, where he received American citizenship in 1938. After the war Grosz planned to return to Berlin, and died there during a visit in 1959.

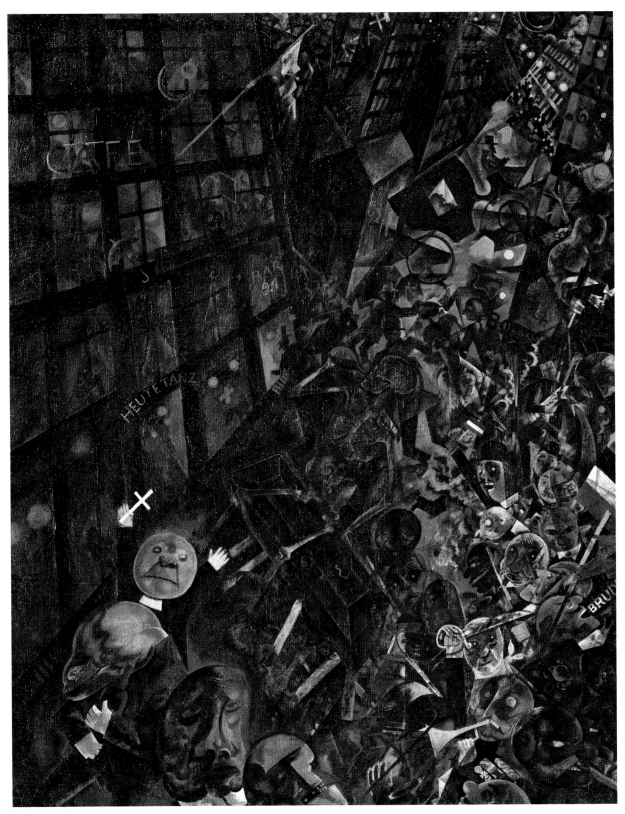

43

pechstein asleep

Oil on canvas, 110 x 74 cm
Bernried, Buchheim Museum

b. 1883 in Döbeln (Saxony), d. 1970
in Hemmenhofen (Lake Constance)

Erich Heckel tended more strongly to sentimentality and melancholy than any other Brücke artist. In view of the idyllic landscapes and human images that dominated his work, the group's move in 1911 from Dresden to the hectic big-city pavements of Berlin must have come as a shock. And as if girding himself against the rush of new impressions, he held fast to his previous motifs after that date. Yet the tenor of Heckel's paintings and prints – his woodcuts are among the best that Expressionism ever produced – nonetheless altered. The brushstrokes grew heavier, the contours harsher, and the palette shifted from powerful complementary colours to subtle, earthy tones. Tragic figures full of melancholy supplanted carefree people depicted in unsullied natural surroundings.

A short time before the move, Heckel produced one of the most beautiful works of his early period, the present painting of Max Pechstein asleep. The history of this canvas is associated with the name of a modern connoisseur.

Lothar-Günther Buchheim began to collect Expressionist paintings, drawings and prints at an early date. In 1951 he founded a publishing house dedicated principally to promoting German Expressionism, which after 1945, when the art business concerned itself solely with abstraction, again threatened to fall into discredit. In 1956 Buchheim published a standard work on the Brücke, followed two years later by a book on the Blauer Reiter. It was also he who rediscovered Heckel's portrait of Pechstein.

At an auction Buchheim acquired a not particularly exciting Heckel painting of 1920–21 that depicted rather wooden-looking nudes on a beach. Thanks to earlier research, he knew the back of the canvas must contain a masterpiece of Expressionism, concealed under a thick layer of white paint – Heckel's portrait of his artist friend, fallen asleep in a long chair, which he had finished in 1910 in Dangast and which the experts had long considered lost. They knew only the small woodcut based on this composition, which was reproduced in 1910 in the catalogue of the Brücke show held at Galerie Arnold, Dresden. Now the sensational picture finally came back to light.

The brushwork is no longer as furious as immediately after the founding year of the Brücke, 1905, and in the following storm-and-stress period, to 1909. Instead, the frontal figure is rendered in expansive flat planes suffused with intrinsic power and grandeur. On an Italian journey in 1909 Heckel had been confronted with the monumental rigour of Giotto (c. 1267–1337) and the Trecento, as well as with the iconic dignity of Etruscan sculpture, and these left their mark on his work. In his Pechstein portrait Heckel also avoided the wild, untamed orgies of colour that had previously dominated much of Brücke art, despite the intense red that determines the overall effect. A general disciplining of painterly means, a tectonic composition, and striking figurative formulae now became Heckel's prime aims. Emotional expression continued to play a key role, but combined with well-considered, rationally controlled form. Heckel also addressed the problem of spatial depth in this period, and attempted to solve it by means of geometric reduction and overlapping pictorial planes.

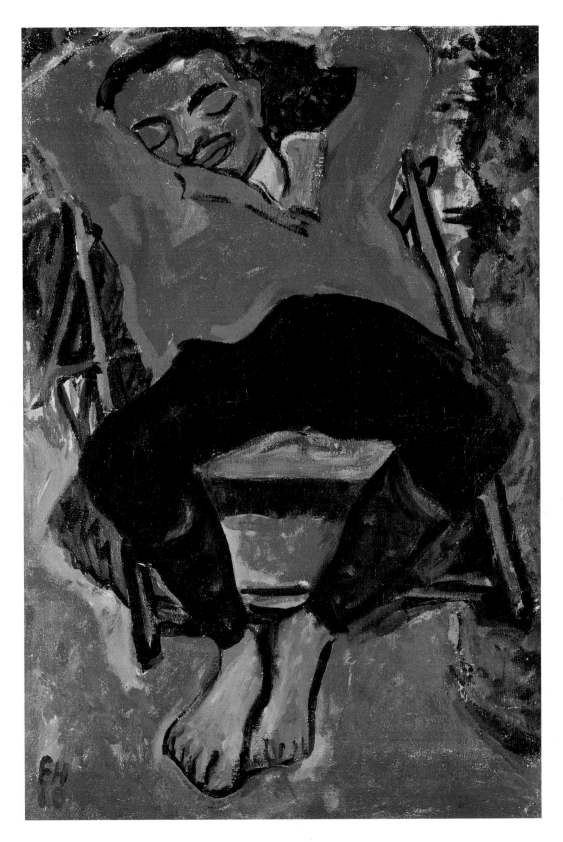

Glass Day

Oil on canvas, 120 x 96 cm
Munich, Pinakothek der Moderne – Staatsgalerie Moderner Kunst

In 1910 and 1911, when Heckel spent relaxing and productive summer months with Kirchner and Pechstein at the Moritzburg Lakes outside Dresden, pictures of bathers, usually female nudes done on the spot, were a predominant subject for him as for the other Brücke artists. The fields of saturated colour were bounded by black contours, the figures simplified and cursorily reduced, the prevailing mood carefree and reflecting that Romantic yearning for a harmonious unity of man and nature, art and life, that characterized Brücke art at that period. Not so much in terms of formal approach as in terms of this fundamental mood, such Expressionist compositions can be compared to Paul Cézanne's *Bathers,* since these, too, aimed at giving form to a vision of an earthly paradise of balance and harmony. The great Cézanne exhibition held in November 1909 at Galerie Paul Cassirer in Berlin gave the Brücke painters an opportunity to thoroughly study his painting.

For Heckel, the year 1911 brought new insights. Although the female nude in the studio or outdoors remained his central theme, his approach in the subsequent works changed decisively under the influence of Cubism and Futurism, but especially after a confrontation with the art of Robert Delaunay. Heckel's theoretical involvement with the Frenchman's work was prompted by Macke, Marc and Feininger, all of whom visited Heckel in Berlin in 1912. *The Glass Day* was his masterful summing-up of this innovative experience.

The painting is no longer executed in the earlier heavy impasto but in thinned oils. Heckel's formerly decorative curving line is supplanted by angular strokes and facetting which transform the motif of a nude figure bathing in a bay into a play of interlocking crystalline figurations. The all-pervading lucid blue of water and sky seems to penetrate even the woman's body in the foreground and the steep coastline in the background. The pictorial space, suffused with brilliant light, robs things of material mass; the colour range conveys an icy, frozen, glassy, quasi spiritualized effect – as already indicated by the title, which, by the way, like the composition itself, anticipated the crystalline fantasies of an Expressionist architects' group that would form

a few years later, "The Glass Chain" (see p. 22). Perhaps it is no coincidence that this major work of Heckel's was executed in 1913, after the Brücke had dissolved.

When war broke out in 1914, Heckel volunteered for the medical corps and was stationed in Ostend, where he met Max Beckmann. With the aid of art historian Walter Kaesbach he was able to continue painting despite his duties. In view of the ensuing self-destruction of old Europe, Heckel placed his hopes in a league of like-minded intellectuals and artists, and grew increasingly intrigued by the circle around the poet Stefan George (1868–1933) – who however despised Heckel's Expressionism. This did not prevent the painter from making George the key figure in murals executed in 1922–23 at the Angermuseum, Erfurt, where Kaesbach had become director after the war and built up a collection of contemporary art – Feininger, Heckel, other Expressionists, and Bauhaus artists. In Heckel's fresco with its predominantly male nudes, the earthly paradise of earlier summers shimmers through. In the elongated figures against a background of forbidding Alpine glaciers, despite the new classicism which has shed its erstwhile Expressionist formal vocabulary, a spiritualization reminiscent of *Glass Day* remains much in evidence.

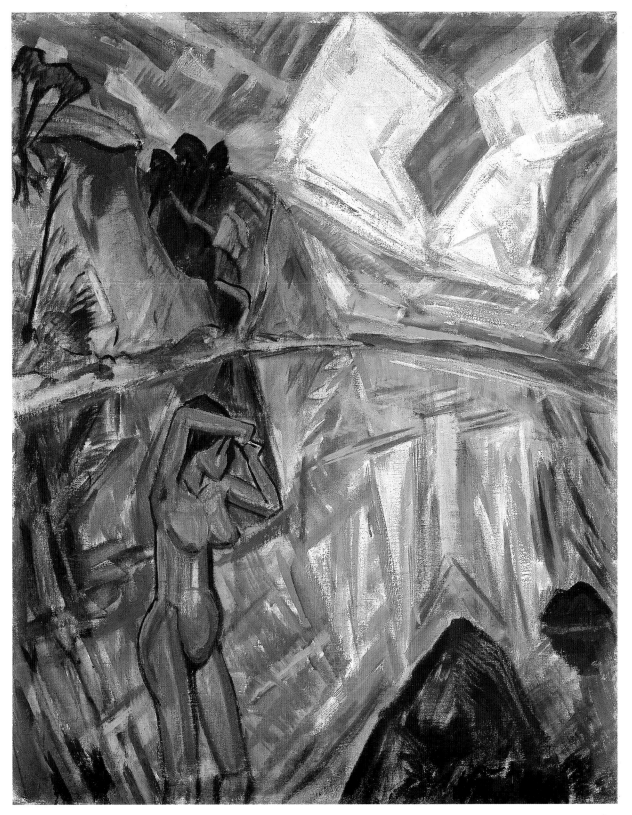

Portrait of the Dancer Alexander Sacharoff

Oil on cardboard, 69.5 x 66.5 cm
Munich, Städtische Galerie im Lenbachhaus

**b. 1864 in Torzhok (near Tver),
d. 1941 in Wiesbaden**

In 1896 Jawlensky came with Marianne von Werefkin to Munich, where they met and befriended Kandinsky. At first the already accomplished artist retained the earthy palette he had learned at the St. Petersburg Academy under Ilya Repin (1844–1930), who was then the dominating personality in Russian painting. Yet he soon shook off this naturalistic approach. The catalyst was a confrontation with van Gogh, modern French art – initially the Nabis, later the Fauves – and subsequently with the Dutch artist Kees van Dongen. In 1905 Jawlensky self-confidently announced that after a stay on the Breton coast near Carantec, he had finally managed "to translate nature into colours in conformance with my radiant soul." Ecstatic emotion conveyed through colour, and the ordering force of planar composition, remained the key concerns of this artist, who, like Kandinsky, was esoterically interested and continually pursued the intrinsic essence and harmony of things.

The following years brought numerous international contacts, and above all collaborative work with Werefkin, Münter and Kandinsky in Murnau, followed by participation in the New Artists Association in Munich and – from 1912 – in the Blauer Reiter. Apart from landscapes, representations of heads began to play a prime role in Jawlensky's oeuvre.

In 1907 he began to concentrate in a very original way on the effects of colours on a plane surface. The resulting paintings convey the impression that the colours have been veritably stretched across the surface. They are contoured in heavy black lines that both define the figures and set them in vibrant motion, as in the superb *Portrait of the Dancer Alexander Sacharoff*. Sacharoff (1886–1963), a close friend of Werefkin and Jawlensky's, was a pupil at the Académie des Beaux-Arts in Paris from 1903 to 1904. A theatre performance by Sarah Bernhardt impressed him so deeply that he decided to become a dancer. In 1904 Sacharoff moved to Munich, where he would later contribute to the development of eurhythmic dancing. Above all in the 1920s and 1930s, tours through all five continents brought him world fame.

Reputedly Jawlensky painted the portrait (from the collection of Clotilde von Derp-Sacharoff) at a single sitting, when the dancer, in make-up and costume, visited him shortly before a performance. And Sacharoff is said to have taken the still-wet picture with him, fearing that the artist might paint it over. The sweepingly rendered area of the figure and the made-up face, lasciviously androgynous – possibly Sacharoff was playing a female role – are dominated by the aggressive red of the costume and mouth, and the black contours of figure and coiffure (probably a wig). The greenish shadows in the face are echoed in the brushstrokes that set the background in an enigmatic staccato that seems to reflect the physical energy of the sitter.

Jawlensky would later employ the synthesis of formal sensibility and expressive mysticism achieved here to create increasingly abstracted faces, in a sort of stenography of the soul. The colours became less and less naturalistic, the pictorial structure ever more geometric. The transcendental presence of Byzantine icons seemed to have been reborn in a configuration derived from Cubism. After the outbreak of the First World War, Werefkin and Jawlensky had to leave Germany. They went to Switzerland. Cuno Amiet, a former member of the Brücke, went back to the couple's abandoned apartment and saved the most valuable objects of art there, including a van Gogh painting.

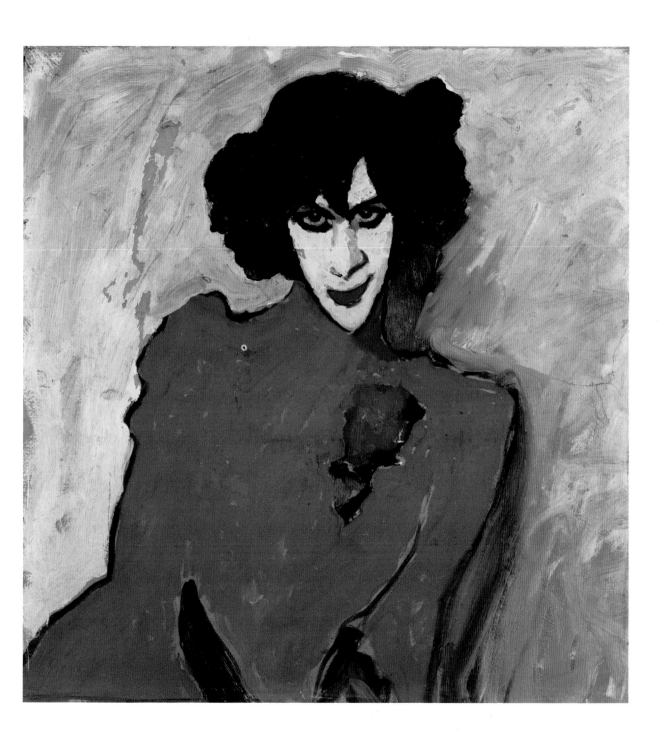

st. Ludwig's church in munich

Oil on cardboard, 67.3 x 96 cm
Madrid, Collection of Carmen Thyssen-Bornemisza, on loan to Museo Thyssen-Bornemisza

b. 1866 in Moscow, d. 1944 in Neuilly-sur-Seine (near Paris)

The artist focuses on the streetside arcades in the lower façade of St. Ludwig's, the Munich University church, which dates from the early nineteenth century. St. Ludwig's is located near Ainmillerstrasse in the erstwhile "artists' neighborhood" of Schwabing, where Kandinsky rented a studio apartment in September 1908. Outside the church portal a crowd of people mills, probably the congregation or participants in a procession, abstracted to glowing dots of colour. The brilliant banner under the middle arch and the group of priests in yellow copes suggests that a Catholic celebration of some kind is going on.

The way Kandinsky brings the short strokes and tiny configurations of glittering, gemlike colour into a dazzling texture, composed in an interplay of light and dark, recalls the folkloristic motifs of the "fairy-tale pictures" in which he depicted his Russian homeland under the influence of French Post-Impressionism and Pointillism in 1906 and 1907. It was no coincidence that in his 1911 book, *On the Spiritual in Art,* Kandinsky referred to Paul Signac's (1863–1935) essay, *D'Eugène Delacroix au néo-impressionisme,* the most important theoretical statement of that group, whose works Kandinsky had already given a place of prominence in the tenth exhibition, in 1904, of the Phalanx group, to which he belonged from 1901 to 1905. The brilliant light contrasted with deep shadows underneath the arches lends the picture of St. Ludwig's both a flickering atmosphere and a highly abstract decorativeness. This, with the saturated colour tones, reflects the deep and lasting inspiration Kandinsky derived from the Fauves, especially Matisse, during a study trip to Paris in 1906–07.

Pictures like *St. Ludwig's Church in Munich* represent the midpoint of Kandinsky's first and decisive phase of development. It began with a literally eye-opening experience. As Kandinsky later recalled, he was standing in front of one of Monet's (1840–1926) paintings of *Haystacks,* Impressionist renderings dissolved into strokes of pure colour, when he realized, "Suddenly I saw a *painting* for the first time." He admitted to not being able to visually identify the motif, which he found embarrassing. A painter had no right, Kandinsky believed at the time, "to paint so unclearly." He had the sense that "the object was missing in this picture." Yet still he was struck by the "unsuspected force of the palette, which had previously been hidden to me and surpassed all my dreams. Painting took on a fabulous power and glory."

Years later, in 1908, when Kandinsky and his partner Gabriele Münter settled again in Munich and began exploring the Upper Bavarian landscape around Murnau with Jawlensky and Marianne von Werefkin, and when they all joined forces in 1909 to found the New Artists Association of Munich, Kandinsky arrived at an approach his friends called "a synthesis" – a reduction of subject matter to flat, coloured forms, rhythmically arranged and anchored by solid contours, which enabled great detachment from natural appearances and their subjective distortion. From this point of departure, Kandinsky then took his next, revolutionary step to abstraction, in the context of the Blauer Reiter group, which separated from the New Artists Association in 1911.

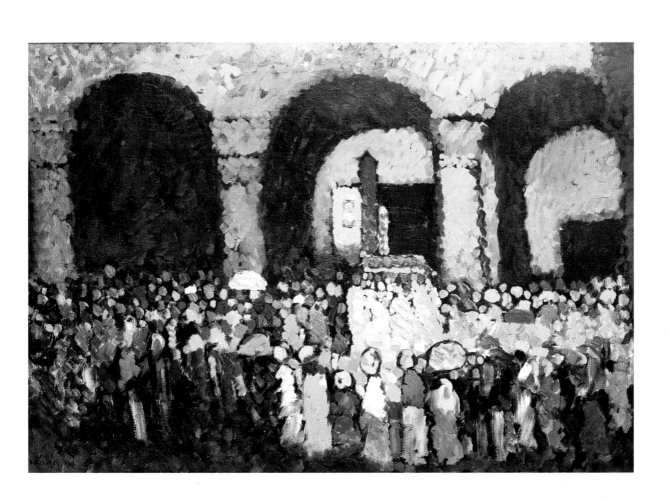

ımprovisation κlamm

Oil on canvas, 110 x 110 cm
Munich, Städtische Galerie im Lenbachhaus

In the Blauer Reiter years, from 1911 to 1914, Kandinsky un-erringly pursued the path to abstraction. This was perhaps the artis-tically most exciting phase of his career, when in his *Impressions* (which, he said, conveyed an impression of "external nature"), *Improvisations* (impressions of "inner nature") and *Compositions,* he retained a modicum of figuration while charging forms and colours with intrin-sic effect. As Kandinsky himself explained in 1914, "In the same pic-ture, in other words, I more or less dissolved the objects, so that not all of them could be recognized at once, and so that these spiritual over-tones could be gradually experienced by the viewer, one after the other. And here and there even purely abstract forms came in of their own accord, forms, in other words, that had to have a purely painterly effect."

In *Improvisation Klamm,* too, the meanings of objects still rever-berate like an undertone in the largely abstract structure. The painting was inspired by an excursion with Gabriele Münter to a valley known as Höllentalklamm, near Garmisch-Partenkirchen, on July 3, 1914. In the upper area one can detect ladders and ropes, at the lower left, a rowboat, and at the lower right, a waterfall. Between these runs a footbridge with a couple standing on it, apparently in Bavarian cos-tume. And yet one by no means has the impression that Kandinsky has simply depicted a country excursion here, let alone invoked an earthly paradise, as August Macke did. It has justifiably been pointed out that the ambience here makes anything but an idyllic impression. Instead, moods of the most diverse kind jar against one another, lend-ing the whole a turbulent, conflicting character – as if the maelstroms of paint were in the process of swallowing up the last remnants of ob-jectivity and figuration.

In keeping with the symbolic language that dominated Kandin-sky's work of these years, the suggestion of an "apocalyptic horse-man" appears in the left-hand section of the picture. A frequent fea-ture of his compositions, this figure stood for the battle against the dragon of worldliness, the avant-garde's battle against hidebound convention, of the spiritual against the superficiality of modern socie-ty. On this point Kandinsky was greatly influenced by the anthroposo-phy of Rudolf Steiner and the theosophy of Madame Blatavsky, which augmented his already strong tendency to mysticism. A new age had dawned, he was convinced, an age in which positivism and material-ism would be overcome, to be replaced by the new ideal of spirituality – actually an old ideal which had already been pursued by German Romantics such as Friedrich and Runge. Kandinsky now set out to convey symbolic meanings not only through motifs but through pure lines and colours, their contrasts and harmonies, their "musiciality" and synaesthetic effects.

Seen against this background, *Improvisation Klamm* looks less like a paradise lost than an attempt to continue those aesthetic bat-tles and incursions into uncharted territory that characterized Kandin-sky's Munich period, despite the dangers that loomed in the real world. For just four weeks after completing this work Kandinsky left Ger-many and returned by devious paths to Russia, where he assumed a key role in the development not only of an avant-garde but a veritably revolutionary art.

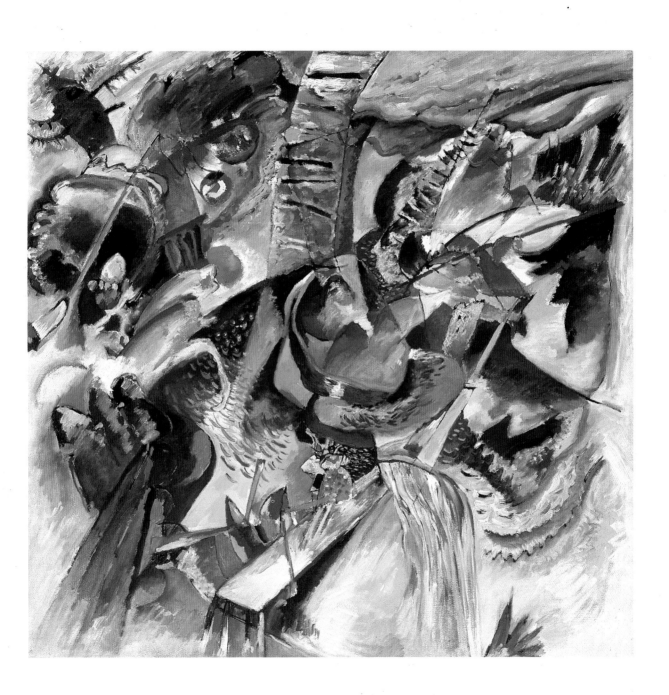

Artiste (Marcella)

Oil on canvas, 100 x 76 cm
Berlin, Brücke-Museum

==

b. 1880 in Aschaffenburg,
d. 1938 in Frauenkirch (near Davos)

Kirchner, criticized Max Beckmann, was never able to escape the influence of French art, something Kirchner himself loudly denied throughout his lifetime. Yet he was already intrigued with Post-Impressionism while still a student of architecture in Dresden, and briefly in Munich. After taking his engineering degree, he became a convert to painting and, on June 7, 1905, joined Bleyl, Schmidt-Rottluff and Heckel to form Die Brücke in Dresden. Now it was the agitated brushwork of van Gogh that left a deep impression on the four. In 1908–09 the Fauves, or "savages", electrified the young German artists, above all Henri Matisse, to whom Galerie Cassirer in Berlin devoted an exciting retrospective. Kirchner marvelled at Matisse's brilliant, flat colour-fields and began to adapt them to his own approach in untiring experiments. They taught him never to entirely lose conscious formal control under the pressure of spontaneous expression. As a result, Kirchner's art developed into one of the most tension-charged of any twentieth-century European painter.

In view of this involvement, it becomes clear why Kirchner should have been primarily interested in the aesthetic, decorative aspects of Matisse's art. In the midst of the formal turbulence and agitation of the Brücke repertoire, of which he was a pioneer, Kirchner nevertheless continually concentrated on a stylization of the planar composition, a rational reduction and clarification of visual vocabulary beyond all sheer expressiveness, as seen in *Artiste (Marcella)*.

From early 1910, two adolescent sisters, Marcella and Fränzi, reportedly the daughters of an artiste's widow who lived in Kirchner's neighbourhood, began to play an important part in the lives of the

Brücke artists. Thanks to their willingness to pose in the nude outdoors, the two girls became the painters' favourite models, and like others before them, likely had a more than platonic relationship with them. The present portrait, which probably represents the fifteen-year-old Marcella, is one of Kirchner's most impressive paintings. It is characterized by intrinsic monumentality and ludicity. The girl has assumed a relaxed pose, one leg drawn up, her head resting on her right hand. The sence is pervaded by a relaxed, introverted mood that is underscored by the cat asleep in the foreground. The apparently so simple effect of the painting should not deceive us as to the refinement of the composition and its skilled disposition of planes. The motifs are arranged on a diagonal, leading from the lower left to the upper right. Smooth, homogeneously opaque colour areas, limited to a few intense hues including a dominant green, and closed contours lend a graceful rhythm to the composition. The unusual, high vantage point, from which the figure is seen diagonally from above, was a brilliant idea on Kirchner's part. It brings the girl close to the viewer, yet at the same time, it shows her turning away as if to escape from any voyeuristic gaze, puts visual and existential distance between model and viewer.

In 1925 in Switzerland – where the mentally and physically shaken Kirchner had retired to a farm near Davos in the last year of the war – he was confronted by original works by Picasso. Their masterful exercises in Cubist facetting tempted Kirchner for a time to make his own attempts at rational pictorial composition. As a result, Kirchner's oeuvre as a whole came to represent both poles of the Expressionist potential: an emotionally-charged, gestural art in heightened colourism *and* a taming of the expressive through conscious control over pictorial means.

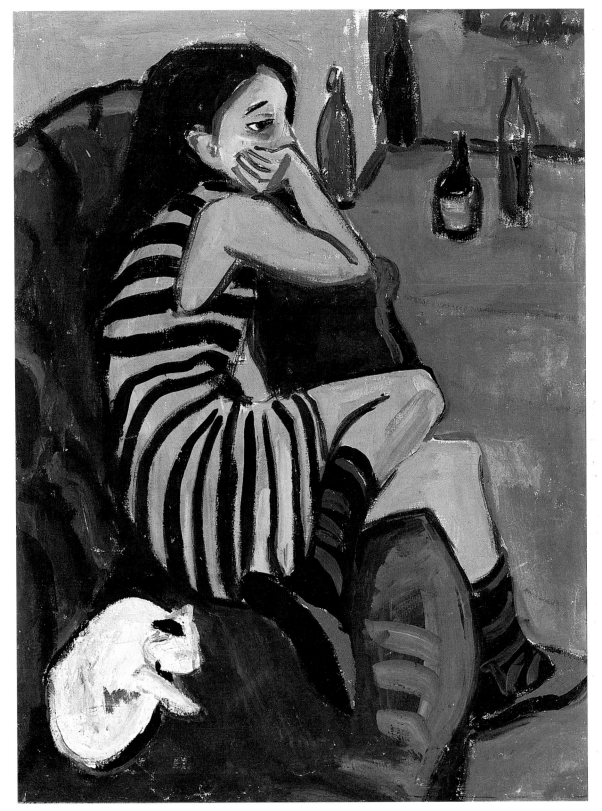

potsdamer platz

Oil on canvas, 200 x 150 cm
Berlin, Staatliche Museen zu Berlin – Preussischer Kulturbesitz, Nationalgalerie

==

In 1911 the Brücke painters moved from Dresden to Berlin, the only true metropolis that Germany had to offer at that period. Now the moloch of the big city became one of their cardinal themes. Kirchner, too, plunged into the symphony – or rather, cacophony – of urban life, with an unprecedented creative furore in which he came to terms, among other influences, with that of Italian Futurism, which had first appeared on the scene in 1909. The Futurists, too, loved the city streets, their garish electric lights and rushing traffic, translating them into a dynamic staccato of lines, a simultaneity of various impressions and events, and interpenetrating visual levels. Kirchner populated his street scenes with prostitutes, decked out as if in the ruffled feathers of birds of prey, bizarre hats, bright feather boas, and tight corsets. Such cocottes prowled in bevies along Friedrichstrasse (whose Café National was the city's best-known streetwalkers' haunt) and around Potsdamer Platz, to which Kirchner made regular excursions from his nearby studio.

The monumental canvas *Potsdamer Platz* is justly celebrated in art history as an illustrious icon of German big-city Expressionism. Gleaming in the background are the red brick walls of Potsdam Station. In the foreground stand two streetwalkers of different ages, both "ladylike", as police regulations demanded. Behind them hover black-suited men, anonymous, faceless. The triangle of the pavement, its shape echoed by the striding legs of the male figures, is thrust like a lance between the converging streets towards the round traffic island, where the female figures present themselves as if on a revolving stage. The combination of forms, round and pointed, possesses clear sexual connotations. The street is suffused by a noxious green, which, as Roland März has said, "fans out in a cold light on wet asphalt, overflowing the banks between pavement and traffic island, inundating it."

An earlier opinion of this picture was less favourable. On February 16, 1916, Franz Servaes wrote in the *Vossische Zeitung* that Kirchner "presents true monstrosities of human figures with distorted limbs, doing ridiculous hopping movements in a surrounding space that totters as if drunk." The fact that one of the women in *Potsdamer Platz* wears a widow's veil indicates that the picture was not finished until after August 1, 1914. That day marked the outbreak of World War I, and from then on, prostitutes were officially required to dress as soldiers' widows on Berlin's streets – strangely patriotic whores!

In 1915 Kirchner volunteered for military service. After only two months he was temporarily discharged, on condition that he enter psychiatric treatment. By this time Kirchner had begun to view war as a "bloody carnival", and wrote, "Now one is just like the cocottes I used to paint. Blurred, then gone the next moment …" In 1917, after attempting to quell attacks of panic with alcohol, morphine and tablets, Kirchner tried to escape them by going to a series of sanatoriums before settling in a farmhouse near Davos. In Switzerland, his art developed from renderings of the forbidding Alpine realm in a monumental Expressionist idiom to experiments in Cubist form inspired by Picasso. In 1937, thirty-two Kirchner works hung in the Nazi exhibition "Entartete Kunst", or Degenerate Art. He felt himself completely misunderstood, as he had always looked upon himself as a quintessentially German artist. Kirchner relapsed into profound depression. On June 15, 1938, he put a pistol to his chest and pulled the trigger.

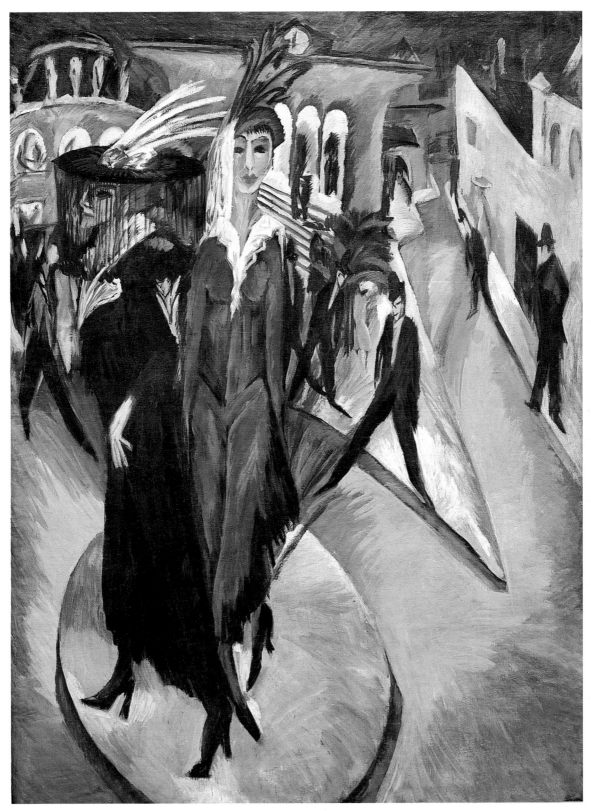

Foehn wind in marc's garden, 1915, 102

Watercolour on paper, 20 x 15 cm
Munich, Städtische Galerie im Lenbachhaus

===

b. 1879 in Münchenbuchsee (near Bern), d. 1940 in Muralto (near Locarno)

The Swiss artist Paul Klee is one of the most outstanding personalities in modern art and also one of its greatest individualists. His oeuvre does not conform to any of the many directions in twentieth-century art. His watercolours, prints and (comparatively few) oil paintings bear little relation in form and content to the common motifs of the period. Klee's stylistic independence goes hand in hand with a brilliant assurance that lends his world-renowned art an enigmatic but irresistible charm. Due to this creative autonomy he is one of the many lone figures who briefly added their voices to the choir of Expressionism without being a member of the ensemble or, indeed, even adhering to the score of the performance.

Nevertheless, Klee was lastingly influenced by his brief connection with the Blauer Reiter. It was his acquaintance with Kandinsky and other artists of the Expressionist vanguard in Munich that brought his breakthrough. His invitation to the Blauer Reiter exhibition of May 1912, to which he submitted seventeen drawings, actually marked the beginning of Klee's international career. Prior to that point, between 1903 and 1905, still living in Bern, he had been active as a draughtsman and etcher of allegorical, grotesque subjects in the wake of Symbolism, formally and substantially related to the Austrian Alfred Kubin (1877–1959), with whom he became friends in 1911. Klee, too, developed a unique linear style and oriented himself to the ambiguity and bizarreness of Romantic literature, such as that of E.T.A. Hoffmann. In early 1912 Klee – like the majority of the Expressionists – confessed his leaning to primitivism: "Because there are still primal beginnings of art, of the kind we tend rather to find in the ethnographic museum or at home, in the nursery (don't laugh, reader)." After a reference to the drawings of the mentally ill, he adds, "All of this must in truth be taken much more seriously than all art museums put together when it is a matter of reforming contemporary art."

Klee's final breakthrough to the "magic of colour" and stylistic maturity resulted from impressions gleaned on a trip to Tunis, undertaken in 1914 with August Macke and the sculptor Louis Moilliet (1880–1962). This journey and its artistic yield became legendary, an absolute apex in the history of modern art. Over the following years the light-flooded watercolours of this period were paralleled by increasingly strict, crystalline abstractions, encouraged by Klee's friend Franz Marc.

This is the context in which *Foehn Wind in Marc's Garden* belongs, one of the most beautiful watercolours from Klee's Blauer Reiter period. It was done on the occasion of a visit to Marc in Ried, near Benediktbeuren, in July 1915, when Marc was on a brief leave from the front. The motif, rendered in an interplay of colours so subtle that "musical" is the only word for it, is abstracted yet still recognizable. We see the wall of a freestanding house, the red roof of a garden house in the midst of dark firs, and a mountain silhouette in the background. Yet ultimately the landscape is reduced to a pattern of Cubistic geometrical shapes that interlock and partially overlap each other. The watercolour also represents Klee's reaction to his reading, in 1912, of Wilhelm Worringer's book *Abstraction and Empathy,* published in 1908. From that point on Klee strove to take an "elevated vantage point" from which he would be able to integrate the "horror-filled world" in a universal context – as here, where Marc's garden is transformed into a universal image. Although this reflects points of contact with the visions of Expressionism, soon, in his Bauhaus period, Klee's art would burgeon into a universe in its own right.

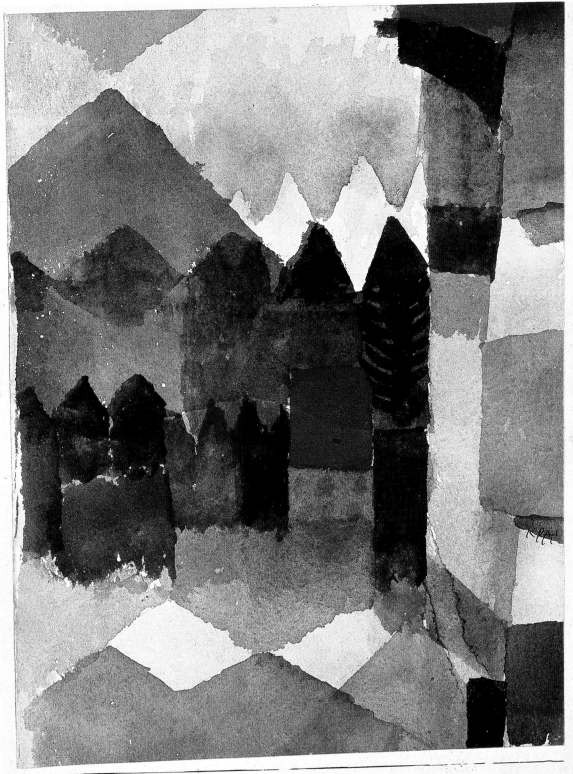

1915 102

Portrait of Herwarth walden

Oil on canvas, 100 x 69.3 cm
Stuttgart, Staatsgalerie Stuttgart

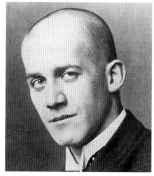

b. 1886 in Pöchlarn (Danube),
d. 1980 in Villeneuve (Lake Geneva)

Oskar Kokoschka began his career as a commercial artist for the Wiener Werkstätte, the renowned crafts workshop in Vienna, while he was still a student at the Vienna School of Decorative Arts. His painting style, dominated by Art Nouveau influence, soon began to show features of Expressionism, such as bizarre idiosyncrasies and distortions, as well as a tendency to psychological penetration. The following year, at the Vienna "Kunstschau", the young artist's tapestry designs were accompanied by drawings and gouaches of young nude girls that touched off a scandal and immediately made Kokoschka the *enfant terrible* of the Vienna scene. Yet there were others, like Gustav Klimt, who recognized his genius.

Between 1908 and 1912 there emerged a series of portraits in thin oils, applied almost like watercolour washes, and agitated lines scratched with the brush handle into the wet paint, which established his early reputation. In these portraits Kokoschka stripped the mask of centuries of convention from the human image. The facial features appear furrowed, the complexion flecked with various hues and incised or scratched off with a brush handle or fine needle. These portraits, accompanied by similarly structured illustrations and lithographs full of nervous lineatures and physical distortions, amount to a laying bare of the sitter's soul. Their intense Expressionist attack is combined with a refinement of brushwork that also makes them masterpieces of a highly cultivated aesthetic.

Kokoschka's Expressionism, as was later often noted, bears "covert Baroque traits". Something ecstatic and visionary indeed suffuses his art, and distinguishes it from that of most of his Viennese contemporaries. This is why his portraits, in particular, are among the most compelling examples of Expressionist art. The nervous blurring of contours, the violent traces scratched into the paint surface, as if in an attempt to plumb the sitter's subconscious mind – some have credited Kokoschka with having "X-ray eyes" and psychoanalytical acumen – combined with a certain morbidity that lies over the faces of the people depicted, amount to a compelling analysis of the intellectual atmosphere of the *fin de siècle*.

Especially in the early portraits, Kokoschka's analytic eye focused on neurotic or even pathological traits. Even the half-figure portrayal of his patron Herwarth Walden, whom he met in Berlin in 1910 and in whose journal, *Der Sturm,* he immediately published his drama *Murderer, Hope of Women*, appears to reflect an overstrung mind, hypersensitivity, or perhaps merely restlessness. Although the reality of the sitter's appearance, one of the main aims of portraiture, is retained, a veil of irrationality seems to lie over the features, as if actual appearances had been abandoned in favour of a spontaneous evocation of inward forces. As in his portrait of Walden, Kokoschka preferred the half-figure portrait type, since it permitted him to underscore the nervous tension of the facial expressions with gestures of the hands, which are usually disproportionately large. The space in the picture, diffuse despite its uniform tone, can be seen as an equivalent to the sitter's state of mind.

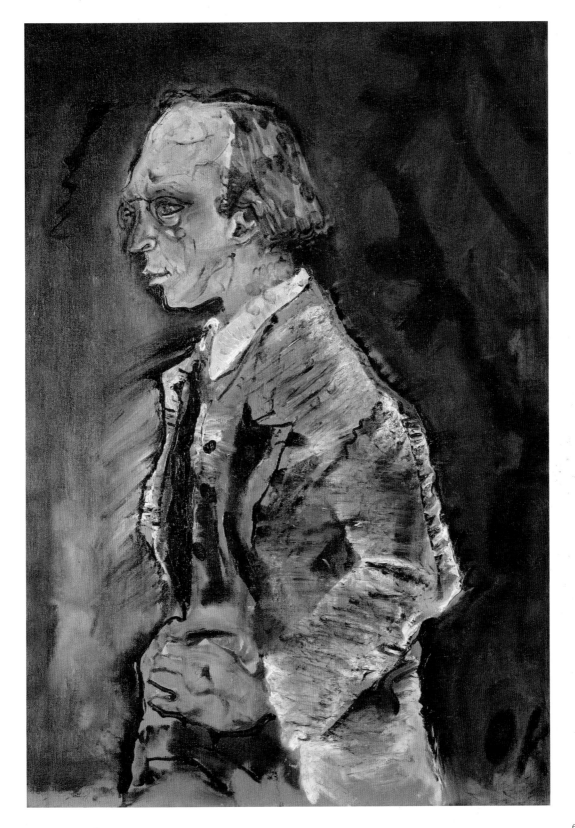

тhe тempest

Oil on canvas, 181 x 220 cm
Basel, Kunstmuseum

After his move to Berlin in 1909 and his activity for Herwarth Walden's journal, *Der Sturm,* Kokoschka gradually abandoned the thin paint application seen in his portrait of Walden. He began to employ thicker colours, an impasto applied in energetic brushstrokes that built the painting surface up into low relief. This manner grew ever more marked after 1912, when Kokoschka, back in Vienna, met Alma Mahler, widow of the composer Gustav Mahler. The ensuing passionate relationship with this lovely woman precipitated in a series of portraits and numerous other paintings, drawings and prints.

The present painting, now in the Basel Kunstmuseum, is a key work in Kokoschka's oeuvre. Finished in 1914, it is also the most famous witness to his great and stormy love. Kokoschka used to tell the following anecdote about the picture. Georg Trakl (1887–1914), an Austrian poet with Expressionist leanings, had come to visit him in his studio. When Trakl saw the yet-unfinished composition, it inspired him to compose a poem on the spot: "The Night". It included the following lines: "Over blackish cliffs / Plunges death-drunken / The incandescent bride of the wind." Trakl pointed at the picture with a pale hand, Kokoschka went on to relate, and titled it *Die Windsbraut* (literally "Bride of the Wind", but generally known in English as *The Tempest*).

In German folklore the term *Windsbraut* connoted the Wild Hunt, a stormy whirlwind that abducted young girls and put them at the mercy of the Wild Hunter. An interpretation of this kind accords well with Kokoschka's painting, which shows him and his lover Alma Mahler drifting on a shell-like wreck through a "universal ocean" – confession of a love that was already threatening to descend into a battle between the sexes and founder on it. This message is conveyed by the contradictory attitudes of the two figures. Next to Alma, who has fallen into a deep and trusting sleep, lies a restless, brooding Oskar, staring into empty space – a complicated relationship put in terms of a universal human parable. The restless traces that plow through the paint congeal – as if in anticipation of Action Painting – into signs and abbreviations for intense emotions. The forms – or better, deformations – flung out into an unreal space are just as "overwrought" as the spotlighted passages in an otherwise subdued colouration. All of this works together to do justice to a typical Expressionist aim, to confront what Karl Kraus termed bourgeois "sexual hypocrisy" with the ideal of a liberated sexuality that would not hesitate to go to extremes even if it meant self-annihilation.

The break-up with Alma Mahler, from which Kokoschka never recovered, occurred in 1914. On the outbreak of war he volunteered for the cavalry. The expressive impasto brushwork in his paintings grew ever more agitated. A despairing attempt to find a surrogate muse in a lifelike doll shed light on the overwrought nervous state Kokoschka was in at the time. This obsession was to pursue him for years. In 1919 he received a professorship at the Dresden Art Academy. Two years later he launched into his superb series of cityscapes. These brought relief from his personal problems – and from Expressionism, which was now replaced by visual impressions conveyed in impressionistic terms.

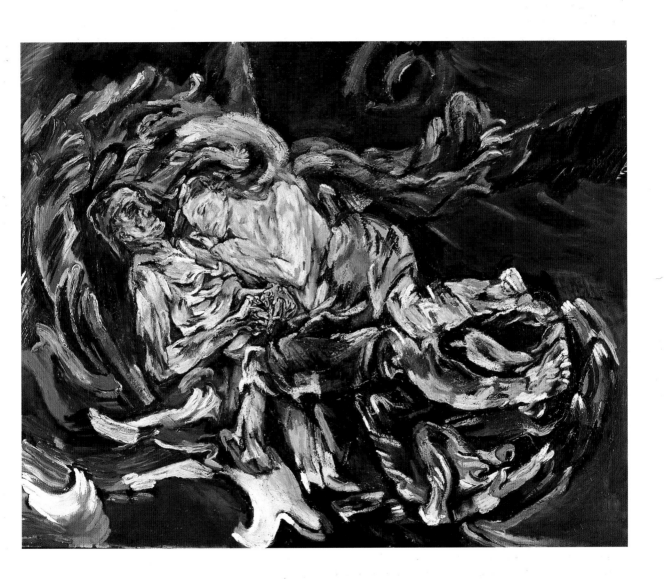

The Fallen Man

Bronze, 78 x 239 x 83 cm
Munich, Pinakothek der Moderne – Staatsgalerie Moderner Kunst

b. 1880 in Meiderich (near Duisburg), d. 1919 in Berlin

When we stand before wood sculptures carved by Ernst Ludwig Kirchner (fig. 6) or Karl Schmidt-Rottluff, view the sculptures of Käthe Kollwitz or Ernst Barlach, we have no trouble in seeing a fundamentally Expressionistic approach in their blocky angularity of configuration, regardless whether it was inspired by exotic or medieval European models. Yet when many authors call Wilhelm Lehmbruck the most significant sculptor of German Expressionism, this faces the viewer of his so different and finely articulated figures with certain difficulties.

Lehmbruck was born near Duisburg, one of eight children of a miner and his wife. Despite difficult circumstances, he was able to attend the Düsseldorf School of Decorative Art from 1895 to 1899. In 1901 he became a master student at the Düsseldorf Academy, where he studied for five years, punctuated by trips to Italy, Holland and England. In 1910 he moved with his wife and child to Paris, where he lived until the outbreak of war in 1914, remaining largely uninfluenced by the formal breakthroughs of the Cubists, some of whom were his friends. In 1915 Lehmbruck was conscripted into medical service in a Berlin hospital. During the war years he produced only a few sculptures, including *The Fallen Man,* 1916, which might be considered a symbol of the generation who fell at Langemarck in 1914. Between October 18 and November 30 of that year, 45,000 volunteers lost their lives, a slaughter that put an abrupt end to the war euphoria felt by so many Expressionists.

The elongated figure with its almost Gothic silhouette has very little surface texture, and the facial features are not pronounced. What remains is drama of expression. Due to the existential experiences of the Great War, many artists, and most of the Expressionists, lost their faith in the "exalted man" of the type Nietzsche had described and Wilhelm Worringer had advocated in his 1908 dissertation *Abstraction and Empathy.* Lehmbruck, who counted Henri Matisse, Amedeo Modigliani, the sculptors Aristide Maillol (1861–1944), Alexander Archipenko (1887–1964) and Constantin Brancusi (1876–1957) among his acquaintances and inspirers, formulated his protest against the disastrous period in terms of a symbolic, melancholy, introverted formal language.

The man, fallen, despairing, crawls on all fours. Yet he is not finished yet. He still supports himself on knees, lower arms and head, and still grips his sword. In view of the original title, *Dying Warrior,* the weakened figure with torso extended horizontally over the long base recalls a bridge between life and death – a moving reply to all conventionally heroic war memorials. The figure's elongated slender limbs enclose an interior space, and embody Lehmbruck's credo, "Sculpture is the essence of things, the essence of nature, that which is perpetually human."

Kirchner and Lehmbruck knew each other from 1912 at the latest and lived not far from each other in Berlin. Though their contacts were apparently not close, there is evidence that the Brücke painter knew and appreciated originals by Lehmbruck. So beyond a general Expressionist philosophy, the two probably shared interests, such as dance, which played an eminently important role in both artists' stylization process. Such similarities led to parallels in their intentions and approaches for a brief period.

Lehmbruck was discharged from the army in 1916 because of a hearing impairment. In 1917 he began to suffer from bouts of deep depression, and in 1919 he put an end to his life.

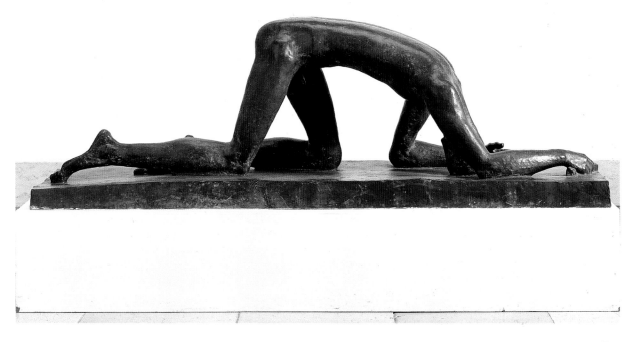

Lady in a Green Jacket

Oil on canvas, 44 x 43.5 cm
Cologne, Museum Ludwig

**b. 1887 in Meschede (Sauerland),
d. 1914 in Perthes-les-Murlus
(Champagne)**

August Macke, one of the most highly regarded German artists of classical modernism, was a wanderer between two worlds. Although his name is inevitably mentioned whenever the topic of Expressionism comes up, emotional excess was not his thing. His art evinces neither the explosive forms, garish colours or primitivism of the kind the Brücke painters loved, nor the sociocritical subjects of Dix, Felixmüller or Grosz, nor the brutal ugliness with which the Expressionists enjoyed provoking the philistines. Quite the contrary. Macke preferred to depict civilized urban scenes, well-kept streets and parks, cafés and shop windows, people on an evening stroll – and above all, colourful women's fashions.

In terms of palette and lyrical approach to nature, Macke's works resemble those of Marc, with whom he was befriended from 1910. Yet he did not share Marc's pantheism despite the fact that he, too, was impelled by the vision of an earthly paradise. And although Macke maintained close contacts with the New Artists Association of Munich and contributed to the *Blauer Reiter Almanach* in 1911, he was sceptical of the mysticism indulged in by Kandinsky, or even by Schoenberg. This may explain why after moving to Bonn in 1911, he never trod the path to abstraction, apart from a few experiments in watercolour and drawing.

Yet there was another new frontier he explored with great success, the frontier that ran between French and German painting. Like no other Expressionist, Macke translated the language of French art into German. And he began to do so at an early date. Already between his studies at the Düsseldorf Academy and a brief stint at the painting school run by Corinth in Berlin (1907–08), Macke immersed himself in French Impressionism and Cubism, which were later supplemented by impulses from Fauvism. But what shaped him above all was his contact, beginning in 1912, with Delaunay, which soon led to oils and watercolours of an expressive yet wonderfully harmonious character, always based on impressions of nature, and always taking the effects of light as their point of departure.

This is confirmed by one of Macke's major works, one of the first done after he and his family moved to Hilterfingen on Lake Thun. *Lady in a Green Jacket*, painted on a well-nigh square format, exudes compositional balance. The lady of the title is not only slightly shifted out of the central vertical axis, she is faceless – i.e., exemplary, like all of Macke's figures of that period. Her gracefully elongated figure is flanked by four smaller figures, farther in the background; a couple each to her left and right, walking towards a wall, and behind them a panorama with river valley and houses simplified in the early-Cubist manner of George Braque. The light-flooded foliage of the trees grows together at the top to form a roof accented in greenish-yellow, their limbs regularly branching in a compositional device perhaps taken from the writings of Leonardo da Vinci, in which Macke immersed himself at that period. The whole is suffused by an enchantment that recalls Romantic paintings by Caspar David Friedrich, with whom Macke shared a penchant for figures seen from the back. Spatial values are coordinated with principles of planar order and brought into a fine-tuned equilibrium. Compositional rhythm is established by prismatically broken hues, transparent, vibrating colour contrasts which themselves seem to be the source of light. When Macke set out in 1914 with Klee and Louis Moilliet (1880–1962) on their now-legendary Tunis journey, he had already long developed that sense of colour which Klee hoped he would find in North Africa.

When World War I broke out Macke donned a uniform, and was killed only a few weeks later. In his touching obituary his friend Marc says: "Of us all, he gave colour the brightest and purest ring, as clear and bright as his entire character."

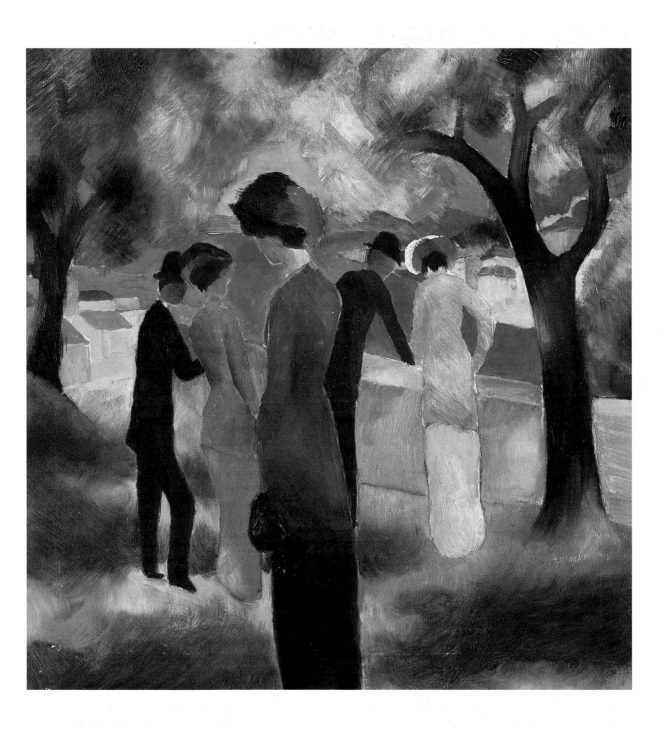

тhe small Yellow Horses

Oil on canvas, 66 x 104 cm
Stuttgart, Staatsgalerie Stuttgart

**b. 1880 in Munich,
d. 1916 in Verdun**

Franz Marc, co-editor of the *Blauer Reiter Almanach,* is probably the best-known animal painter in modern art. Of course this label does little justice to Marc's qualities, which Kandinsky later described as follows: "Everything in nature attracted him, but above all animals … But he never lost himself in details, and for him the animal was always only one element in the whole … What attracted him was the organic whole, in other words, nature in general." Marc himself, who originally wanted to become a pastor, described his vision of a religion of art thus: "Art is metaphysical, will become so … Art will liberate itself from human ends and human desires. We will no longer paint forests or horses in the way they appeal or appear to us, but *how they really are,* how a forest or a horse themselves feel, their absolute being …" A new religion would be born, as Marc repeatedly stated in a correspondence full of references to the anthroposophy of Rudolf Steiner and echoes of German Romanticism. On its altars would grow a new art whose spiritualized lyricism would mirror the "animal soul". Accordingly Marc attempted to capture the spiritual purity of animals by increasingly stylizing their forms, a process that by the end of his brief artistic life had led him to abstraction (fig. 3).

The Small Yellow Horses gives a good sense of the sacred utopia Marc envisaged. He takes up the idea of paradisal harmony by basing his animal depiction on a pattern traditionally employed for depictions of human figures. His preference for groups of three may go back to the convention commonly used since Antiquity to depict the Three Graces. Marc sets the three powerful horses' bodies circulating in a cosmic landscape panorama and at the same time within their own force field, their gracefully rounded forms in complex interaction. There is not one line too many, and, to the artist's mind, every colour field possesses symbolic meaning: the blue representing the "male principle, severe and intellectual", contrasted to a yellow representing the female, gentle, joyful, sensual principle. The red, in turn, embodies matter, "brutal and heavy", and is being fought by the two other colours in an attempt to overcome it.

Marc, studying first philosophy at the university then art at the academy, took two study trips to Paris that confronted him with the key stylistic directions of the French avant-garde. After summering in Lenggries in 1908, he began increasingly to concentrate on depictions of animals, to the point that the human image almost entirely disappeared from his art. In 1909 Marc moved from Munich to the country idyll of Sindelsdorf in Upper Bavaria. Yet he did not lose contact with happenings in the art centre, developing, for instance, a deep friendship with August Macke. Artistic exchange within the Blauer Reiter and above all an involvement with Robert Delaunay, whom he met in 1912 on a visit to Paris with Macke, increased the degree of abstraction of Marc's painting and the evocativeness of his palette. In September 1912, in the Berlin journal *Der Sturm,* he published a woodcut to a poem by the Expressionist poet Else Lasker-Schüler (1869–1945). This marked the beginning of a long friendship between two like-minded artists. It precipitated in a series of wonderful watercolour postcards by Marc and Lasker-Schüler, first published as "Letters to the Blue Rider Franz Marc" in the journal *Die Aktion.*

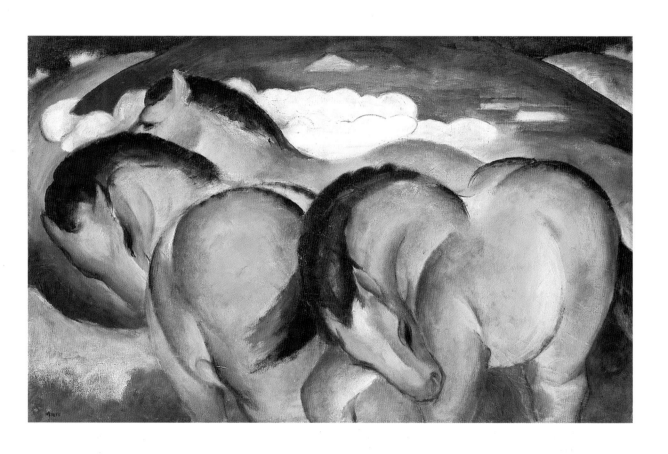

Tyrol

Oil on canvas, 135.7 x 144.7 cm
Munich, Pinakothek der Moderne – Staatsgalerie Moderner Kunst

In 1912 the events in Marc's life came to a head. While in Berlin he met the Brücke painters, and immediately made a selection of their prints which would subsequently be shown at the second and final Blauer Reiter exhibition in Munich. And conversely, the Munich artists were present that year in Berlin, where Herwarth Walden introduced them to the public as "German Expressionists". That autumn Marc went to Bonn with his friend Macke. From there they continued on to Paris, to visit Robert Delaunay, who impressed them both, though Macke far more than Marc. The latter, for his part, was enthusiastic about the Futurists, whose pictures he hung and intensively studied in a large Bonn exhibition mounted after his return from France. Their influence is apparent in one of his masterpieces, the oil *Tyrol.*

In 1913 Marc was involved in a great undertaking. He played a material role in organizing, at Herwarth Walden's Berlin gallery Der Sturm, the "First German Autumn Salon". Represented were ninety artists from France, Germany, Russia, Holland, Italy, Austria, Switzerland and the United States. A great deal of room at this, the most important overview of modern art prior to the First World War, was accorded to Delaunay, Marc, Macke, Kandinsky, Campendonk, Münter, Klee, Kubin and the Futurists. Marc showed seven paintings, including his renowned *Tower of Blue Horses* (lost; based on a composition on a New Year's postcard of 1913 to the poet Else Lasker-Schüler), *The Poor Land of Tyrol,* and *Tyrol.* Marc had travelled to Tyrol with his wife Maria in March 1913. In the first painting done thereafter (New York, The Solomon R. Guggenheim Museum) he arranged houses, gloomy cemetery crucifixes and a few animals in a landscape seemingly pervaded by profound resignation. The next picture, *Tyrol,* was more strongly marked by the traditional interpretation of the Alps as a scene of the "sublime", the potentiated locale of man's insignificance in face of the vastness of nature. After being briefly on view in the Autumn Salon, the painting was removed by Marc and reworked in 1914, shortly before he was sent to the front lines, when he added the madonna on a crescent moon. Every element of this forbidding landscape with farmhouses cowering at the base of a mighty mountain-side seems absorbed into the diagonal facets pulsating with Futuristic energy. Luminous crystalline shapes are penetrated by black passages. A huge charred tree trunk in the foreground recalls an apocalyptic scythe. No living creatures are to be seen; Marc's beloved animals have fled. At the top right a blood-red sun shines behind threatening peaks, while a second sun, the black sun of the Apocalypse, appears in the midst of the turbulence and steep mountains. The suns are counterbalanced by several crescent moons at the upper left. The madonna on a crescent moon, focus of the cosmic turbulence, is simultaneously a symbol of divine grace and an apocalyptic motif – the pyramid of her garment spreads over the farmhouses like a protective cloak. From the figure emerge rays that perpendicularly intersect the mountains. No other work of Marc's, with the exception of a few planned Bible illustrations, conveys such a clearly religious statement. In addition, the painting seems to announce an abandonment of the theme of animals, which the artist began to consider in 1913 and increasingly put into practice as he set out on the path to abstraction (fig. 3).

In 1914, halfway down this path, Marc volunteered for military service. In 1916, aged thirty-six, he fell at Verdun. Marc's *Tower of Blue Horses* was included in the "Degenerate Art" exhibition of 1937. The Nazis sold many of his works out of the country. Yet after the Second World War, his art experienced a second, true triumph. In 1989, one of his temperas brought DM 2,600,000 (approx. $1,300,000), the highest price ever paid for a work of art at a German auction to that date.

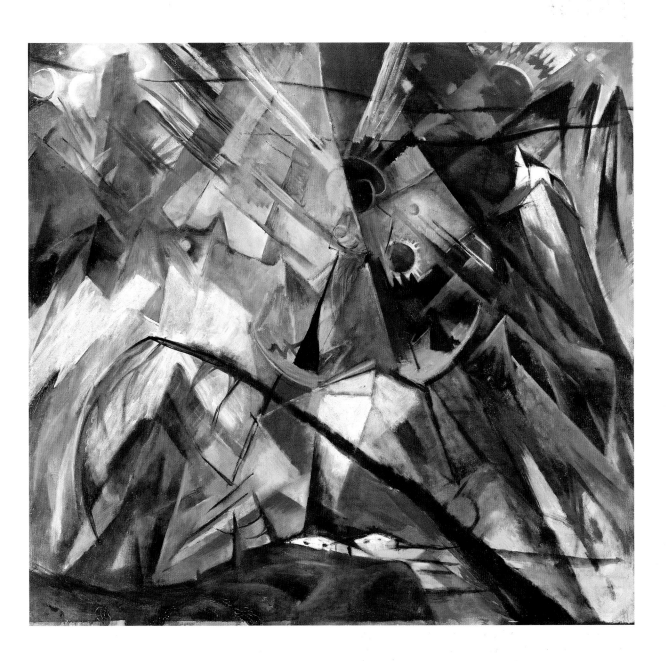

apocalyptic city

Oil on canvas, 79 x 119 cm
Münster, Westfälisches Landesmuseum für Kunst und Kulturgeschichte

**b. 1884 in Bernstadt,
d. 1966 in Darmstadt**

Meidner has been called the most expressionist of the Expressionists, but this is true only of a limited part of his total oeuvre, which is characterized by numerous caesuras. After studying from 1906 to 1907 in Paris, where he met Amedeo Modigliani, he moved definitively to Berlin in 1908, the city which he described as "the intellectual and moral capital of the world". In 1912, together with two other Jewish artists, he founded the group known as the "Pathetiker", whose breakthrough was assisted by Herwarth Walden's gallery Der Sturm. At that time, Meidner, whom George Grosz had described as a restless little man, "like a figure out of one of E. T. A. Hoffmann's short stories", and who, in his youth, had devoured Nietzsche's *Thus Spake Zarathustra*, had begun creating not only his portraits in oils, Indian ink, and other graphic media, but also his analytical self-portraits, which, in his own words, were "consciously demonic". All the energy was concentrated in rhythmic lines, zigzag folds, an almost caricature-like exaggeration, and in gestures of great pathos.

In Berlin, encouraged by Max Beckmann, an extra component was added in the form of an emergent big-city euphoria, the fascination with a tumultuous and effervescent urban world, which was responsible for, among other pictures, the series of "Apocalyptic Landscapes" up to 1916, on which Meidner's fame was based. These were panoramic fantastical cityscapes, depicted from a bird's-eye perspective, bursting open as if under bombardment from the cosmos. The city in the present painting is the victim of such an infernal catastrophe; ant-like, a few people are fleeing from the exploding stars and the terrestrial conflagration. The tectonic interplay of verticals and horizontals is dissolved in distorted and disparate perspectives and shifted proportions. The whole structure is torn apart extreme colour contrasts and by diagonals reminiscent of comets' tails. In this and related compositions can be seen the extent to which Meidner was influenced by the flickering colourfulness and splintered picture backgrounds of the Mannerist El Greco (c. 1541–1614), by the Italian Futurists (whose work could be seen in Berlin in 1912), and by the Robert Delaunay's prismatically fanned out views of the Eiffel Tower. In addition, he was familiar with the photographic double-exposure technique. For the film *Strasse* (Street), directed by Karl Grune in 1923, Meidner created the sets, staging a big-city street once more, with collapsing façades, houses seemingly transfixed by deep shadows, and the atmosphere heightened yet further by cones of light.

The "Apocalyptic Landscapes" resulted, it is thought, from a premonition of the First World War. This may well be true in part, but above all they were triggered by Meidner's intense involvement with ancient Jewish prophecies of doom and with the New Testament Book of Revelation. In 1918, after the war, he was active in the revolutionary "Arbeitsrat für Kunst", a kind of artists' soviet, and by 1923 at the latest he had turned his back on Expressionism and the "modern spirit" and rediscovered the faith of his fathers, orthodox Judaism, to which he gave expression in naturalistic symbolic depictions. Meidner, previously also at home in proto-expressionist literary circles, and himself – like Barlach, Kokoschka and Kubin – a superb writer, was in 1937 branded a "degenerate Jew". From 1939 to 1952 he lived – reluctantly – as an exile in England, before returning to Germany, where in 1964 he received the Bundesverdienstkreuz, the Federal Republic's award for merit.

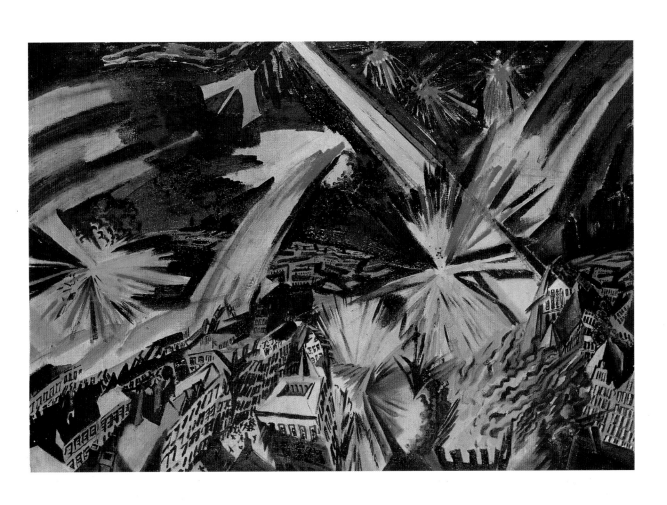

self-portrait with camelia sprig

Oil on wood, 61.5 x 30.5 cm
Essen, Museum Folkwang

**b. 1876 in Dresden,
d. 1907 in Worpswede**

The year 1905 was relevant not only as the founding year of Die Brücke. It also marked an important transition for three northern German artists, Nolde, Rohlfs and Modersohn-Becker, all of whose art then began to take an emotional, expressive direction. Paula Modersohn-Becker had gone in 1899 to Worpswede, a village outside Bremen where Fritz Mackensen had established a colony of landscape painters in 1889. One of them, Otto Modersohn, married the young Paula, who soon met the poet Rainer Maria Rilke in Worpswede. Everyone in the group back then dreamed of a new unity of man and nature. The small community, which promised an escape from the anxiety and loneliness of modern city life, as well as freedom from the constrictions of the academy, seemed a perfect setting to realize this utopian vision.

Modersohn-Becker had become familiar with a suitable lyrical approach to nature in the works of Cézanne and, even more, of Gauguin, during her brief studies in Paris. Back in Worpswede, she spontaneously began to depict ordinary rural people, using earth colours and heavy contours. Her concentration on broad expanses of colour and rigorous outlines owed much to Gauguin.

Her *Self-Portrait with Camelia Sprig* is one of the finest examples of self-searching in art, something by which Modersohn-Becker always set great store. At the same time, the small painting reveals a knowledge of reproductions of Egyptian mummy portraits of the second to fourth centuries B.C., striking coffin depictions with overlarge eyes, clearly delineated faces, reduced, flat forms, and expressions of great mystery. Beyond this, Modersohn-Becker accentuates the colour contrast between the sonorous browns of the shadowed, strict-

ly frontal bust and the light-flooded blue of the background, which surrounds her head like an aureole. The camelia sprig, demonstratively placed on the central vertical axis, is a traditional symbol of growth and fertility.

Finally, as the pervading melancholy of this portrait reveals, a stranger ultimately remains a stranger, even in an apparently idyllic, unsullied rural setting. Modersohn-Becker was in fact the only Worpswede artist to sense the danger of provinciality that goes hand in hand with an idealization of country and peasant life. As she complained in a letter of February 29, 1900, to Otto Modersohn, "We cleave to the past too much in Germany. All of our German art is too bogged down in the conventional … At any rate, I think more highly of a free person who consciously puts convention aside …"

In 1905 Modersohn-Becker found her way to just such an unconventional art, emotionally powerful and far from the idealization of genre scenes. During a second Paris sojourn she again studied Cézanne and Gauguin, as well as the Nabis. Back in Paris the following year, she saw the first paintings by the Fauves. In 1907, shortly after the birth of her first child, she died in Worpswede.

Although she avoided all Expressionist exaggeration, especially in terms of bright palette, Modersohn-Becker's art has an emotional depth and power that gives it a definite, if reserved, affinity with Expressionism.

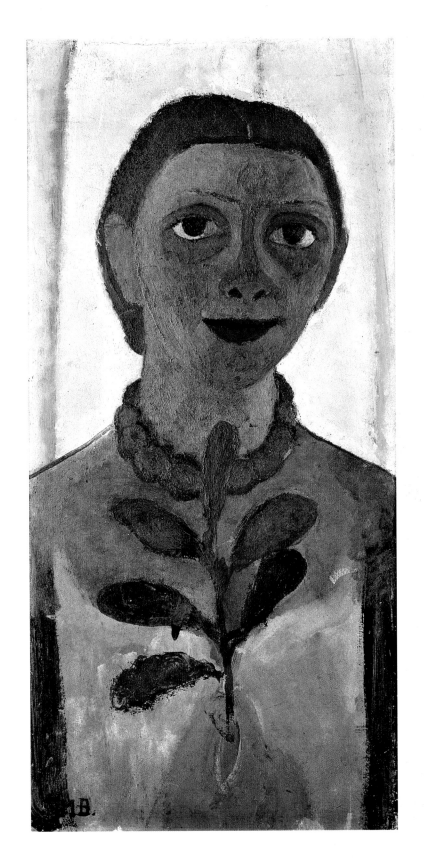

gypsies with sunflowers

Distemper on burlap, 145 x 105 cm
Saarbrücken, Saarland-Museum

b. 1874 in Liebau (now Lubawka),
d. 1930 in Breslau (now Wroclaw)

"Gypsy Mueller" was the nickname of the painter who became the last member of the Brücke in 1911. Reputedly his mother was a gypsy. At any rate, Mueller felt attracted from boyhood to the carefree life of these vagabonds on the margins of society, as he did to those slender young nude girls lost in thought among the reeds or bathing in woodland lakes who embodied the Expressionist ideal of a reconciliation between art and life.

After training as a lithographer in Görlitz, Silesia, Mueller studied in 1894–96 at the art academies in Dresden and Munich, where he felt out of place. He received encouragement from the author Gerhart Hauptmann (1862–1946), to whom he was distantly related. He made the acquaintance of Paula Modersohn-Becker and, more importantly, the sculptor Wilhelm Lehmbruck, whose spiritualized figures apparently made a lasting impression on him. Among the Brücke artists Mueller, with his quiet, introverted personality and lack of interest in provocation and posing, played an outsider's role. Technically, too, he set a personal accent by adopting distemper instead of oil in 1911. Distemper colours dry in nuances that differ from those with which they are applied. Their handling therefore entails an exact and careful consideration of the drying process. Mueller was a master of distemper and lent his pictures an inimitable charm, a friable airiness and poetic immateriality. At the same time, this technique fairly demanded the use of large formats and monumentally simplified forms. Mueller's burlap painting surfaces (often from unstitched sugar sacks) occasionally recall the rough-textured surface of frescoes.

Gypsies with Sunflowers, finished in 1927 during a period of emotional conflict arising from a difficult personal relationship, indicates Mueller's fidelity to his established style and favourite subject matter even in the face of official postwar recognition of a kind accorded to no other member of the Brücke. In spring 1919 the artist was offered a professorship at the Breslau Academy (which admittedly could not prevent 357 of his works being confiscated and for the most part destroyed in 1937). The same prototype adolescent girl, with identical features in narrow faces, dark, medium-long hair, and "Gothically" slender figures, appeared over and over again in his work. Even the nursing mother in the present picture takes on the standardized youthfulness of the girl who is compared to the open sunflower beside her. The actual world of gypsies, the surroundings of their village, are suggested, but without a trace of sociocritical interpretation. Even the melancholy undertone that now makes itself felt points in a different direction. The outsiders of modern industrial society seem embedded in an idyllic, Romantic context, reflecting a yearning for a paradise lost much like that felt by Gauguin and projected in his paintings of Tahitian islanders. Between 1924 and 1929 Mueller found material for his gypsy paintings on travels to Hungary, Dalmatia, Rumania and Yugoslavia. For a time he even lived in a gypsy camp outside Budapest. Using such experiences he also produced his famous "Gypsy Portfolio," nine partly hand-tinted colour lithographs which are among his most outstanding works of graphic art.

Apart from early experiments, Mueller's oeuvre remained stylistically and thematically quite limited. In 1926, four years before the artist died of tuberculosis, art critic and playwright Carl Einstein noted in his book, *Art of the 20th Century,* "With an easy laxness Mueller sweetens nudes or German landscapes … Charm may occasionally be achieved, but most [of his art] sinks into a shallow saccharinity of blue and green and monotonous quiet lineature." Today voices of this kind may have become rarer, but they have not grown entirely silent.

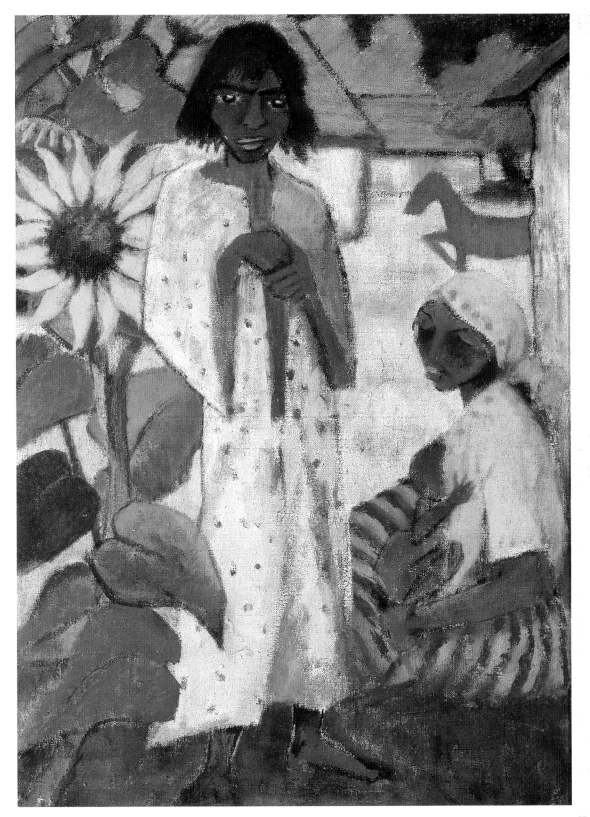

schoolhouse, Murnau

Oil on cardboard, 40.6 x 32.7 cm
Madrid, Collection of Carmen Thyssen-Bornemisza, on loan to Museo Thyssen-Bornemisza

b. 1877 in Berlin, d. 1962 in Murnau

At first glance it seems quite unassuming, this small view of the schoolhouse in Murnau. And yet this picture stands at the beginning of a decisive turning-point in Münter's development.

At the age of twenty Gabriele Münter enrolled in the School of Art for Ladies in Düsseldorf, with the intention of becoming a drawing teacher, the only art career then socially acceptable for women. After an inheritance brought financial independence, she risked the leap into freelance art. In 1901 she settled in Munich, where she became acquainted with Kandinsky. In 1904 the two set off on journeys that took them to Venice, Tunisia, Holland, France, and, on more than one occasion, to Russia. As a member of the New Artists Assocation of Munich and a short time later of the Blauer Reiter, Münter advanced to become one of the most significant southern German Expressionists of the first hour.

In summer 1908 Münter, her partner Kandinsky, Jawlensky and Marianne von Werefkin explored the foothills of the Bavarian Alps from their base in the provincial town of Murnau on the Staffelsee. "It was a lovely, interesting, enjoyable period of work with many conversations about art," recalled the artist in her diary.

A document of this fruitful collaboration was the present view of the schoolhouse, the fourth done on that August 27, as indicated by the precise dating in the lower centre. It depicts one of Murnau's largest and plainest buildings, in a radically simplified composition of a total of eight flat elements separated by heavy contours. The colour fields enclosed in these contours have hardly any internal nuances, modelling or shading, being enlivened solely by short, colourful brushstrokes. This reduction to a nearly geometric planar order neverthe-

less contributes to the equilibrium and harmony of the detail depicted. In contrast to this calculated balance, the thinly brushed areas, sketchy details and unpainted cardboard ground suggest an incredibly rapid painting process charged with intuitive expression.

With this and comparable paintings began a transition from Münter's earlier Impressionist-oriented style to an Expressionism that was developed jointly by her, Kandinsky and Jawlensky that summer in Murnau. In this regard Münter relied on various sources, apparently suggested above all by Jawlensky: Gauguin and van Gogh for the contoured colour fields, Munch and Matisse's Fauvism for the range of hues. Also, similar formal approaches were found in examples of the folk art of *verre églomisé*. "After a brief period of torment," she wrote, "I made a great leap – from copying nature – more or less impressionistically – to feeling a content – to abstracting – to giving an extract." However, Münter never took the final step to abstraction, as Kandinsky did. When war broke out she followed him to Switzerland, yet soon their paths diverged. Münter went through years of personal and artistic crisis before finally returning to painting at the end of the 1920s.

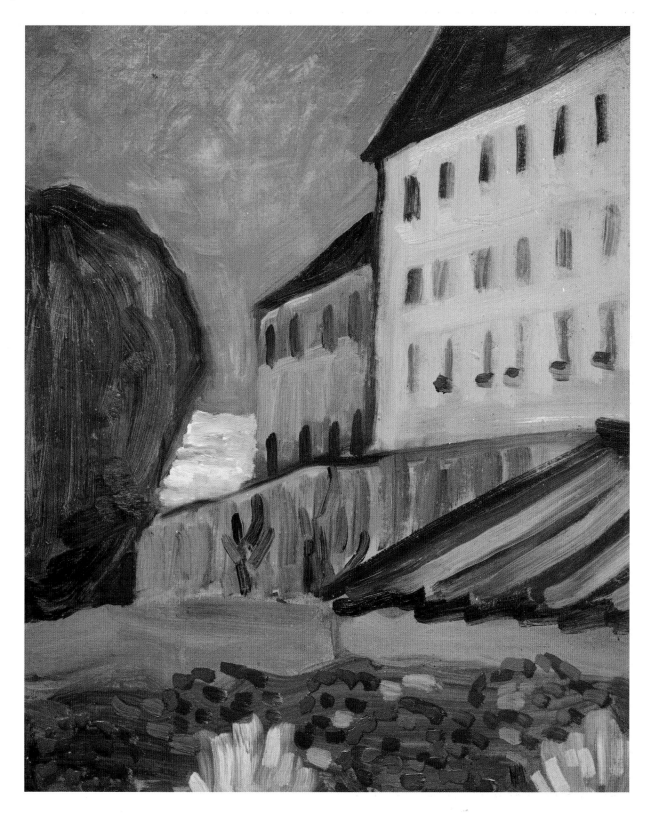

The Legend of
St. Maria Aegyptiaca

Oil on canvas, triptych: central painting 105 x 120 cm, wings 86 x 100 cm each
Hamburg, Hamburger Kunsthalle

b. 1867 in Nolde (near Tondern),
d. 1956 in Seebüll (near Neukirchen)

Emil Hansen, born in Nolde near Tondern, Schleswig (now Tønder in Denmark), adopted his birthplace as a pseudonym in 1902. Training as a furniture draughtsman, studies at the Karlsruhe School of Arts and Crafts, from 1892 teacher at the St. Gallen School of Arts and Crafts, many study trips – these were stations on Nolde's path to becoming one of the most outstanding graphic artists, watercolourists and oil painters of Expressionism. When he settled in 1903 on the island of Alsen and began to concentrate on garden and floral motifs, his palette gradually developed to become a vehicle of ecstatic emotion. In 1906, in the circle around Karl Ernst Osthaus, Nolde studied works by van Gogh, Gauguin, Ensor, and met Edvard Munch.

The suggestiveness of his colour and the intuitive passion of his painting attack brought Nolde into proximity with the aims of the Brücke, to which he belonged from February 1906 to the end of 1907 and with whose members he later remained on friendly terms. To cite George Grosz's description of Nolde's working procedure during those years, he "no longer painted with brushes. He later said that, when the inspiration took him, he threw away his brushes, dipped his old paint rag into the paint, and smeared around on the canvas in blissful intoxication." Nolde's pictures looked as if they had been produced by liquid colours that had bled into each other, unconstricted by contours, which led to the frequent impression of misdrawing.

His group of religious paintings, commenced in 1909, was one of Nolde's major contributions to modern art. The compositions are entirely focused on the transcendental, spiritual meaning of the scene depicted. The figures are brought up very close to the viewer; their masklike faces often have a distorted expression verging on caricature; the eyes stare, the features are primitivistically coarse, and the whole of the canvas is suffused by saturated, luminous colours which, in Nolde's own words, reflected "the mystical depths of human-divine being."

In the middle panel of the present great triptych of 1912 devoted to the legend of Maria Aegyptiaca, the saint, clad in a bright red cloak, is shown in prayer with arms raised ecstatically towards heaven. A blue-clad Madonna statue stands in a niche in the golden yellow wall. Nolde, a Protestant, lends the impassioned worship of Mary an inspirational force of the very kind which earlier church reformers and opponents of Mariolatry denied it. Yet the former prostitute from Egypt does not turn to the idol, but addresses her ecstatic prayer straight to God. The left-hand panel depicts her earlier licentiousness in a range of glaring colours. Mary's figure is suffused with golden yellow, and the nipples of her heavy breasts shimmer purple. Grinning with lust, she extends her arms towards three greedy, grotesque male figures clad in blue, green and purple. On the right panel, the converted sinner and penitent lies in the throes of death. An ascetic says a prayer over her prostrate body, as a lion awaits his chance to spring and play his part in the miraculous event. The background of the "waste land" is formed by a jungle in gradations of green and blue – perhaps a sultry, exotic counterpart to the Christian Garden of Eden.

Like his other religious compositions, this triptych was not meant to be viewed as an altar painting. All of them, as Nolde stated, were "artistic evocations, intended to serve art".

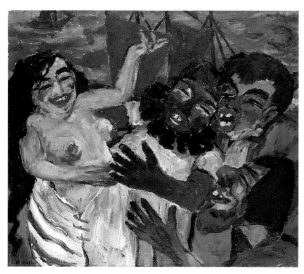

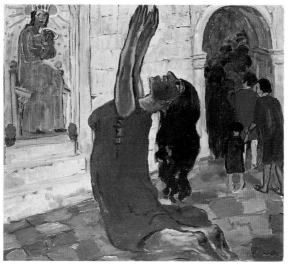

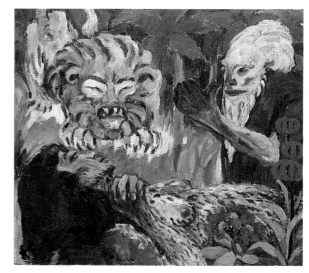

Tropical sun

Oil on canvas, 71 x 104.5 cm
Seebüll, Nolde-Stiftung

When in July 1905 Nolde returned from Switzerland to northern Germany and the island of Alsen, he stopped over in Weimar and visited a Gauguin exhibition, noting, "I have never before seen such glorious colours in modern art." The exotic realm to which the French artist escaped became a destination for which Nolde also yearned. Not that he was a Romantic escapist. Rather, he pursued a well-defined artistic goal – to recover the "primal", the source of all creativity that had been buried under the flotsam of civilization. In 1911 Nolde planned a book on "Artistic Manifestations of the Natural Peoples", in which he intended to confront the ritual objects of the "savages", as he noted in his autobiography, with the "saccharine tasteless forms" exhibited in the "glass cases of the salons". The book was never published. But while preparing it Nolde studied objects by the Egyptians, Assyrians, the indigenous peoples of Africa, southeast Asia and the South Pacific, with which the Berlin Museum of Ethnology overflowed. Two years later the forty-six-year-old artist took an opportunity offered to him and his wife to accompany a scientific expedition to New Guinea. Their trip took them to the South Pacific by way of Russia, China, Korea and Japan. In addition to numerous sketches and watercolours, Nolde executed nineteen oils in the provincial town of Kaewieng, on the northwest point of present-day New Ireland, an island the German colonial administration of the day called New Mecklenburg. One of this group of works is *Tropical Sun,* which was preceded by a small preparatory drawing.

Having gone down to the beach, Nolde looked from sea level towards the horizon, where the sun is either rising or setting. The horizon line divides the horizontal format just below its central axis. Visible there is the dark green, forested silhouette of Nusa Lik island. This undulating form penetrating the composition from the left finds a correspondence in the white cumulus cloud above the horizon and in the foaming breakers in the foreground. The sun stands over the treetops like an incandescent red disc in the midst of a radiant aureole that is surrounded by darker cloud formations. The range of colours, applied for the most part in broad, impasto strokes, rises to a frenzy of vermil-ion red, cadmium orange and cobalt violet. The individual tones are no longer applied wet in wet as in Nolde's earlier landscapes but spread into expansive areas. Their intensity or brilliance is not to be confused with garishness, as the artist repeatedly emphasized in view of his impressions of the South Pacific. Far from requiring any expressive exaggeration, he said, these colours conformed with actual phenomena in the tropics.

Nolde did not address the First World War in his art. He painted no visions of destruction or apocalyptic landscapes like, say, Meidner. Instead, to his tropical paintings Nolde added northern German lowland landscapes, coastlines and gardens, replying to the vicissitudes of the age by charging nature and religious subjects with an optimistic mysticism. Kirchner described Nolde's art in his diaries as "often morbid and too primitive". He thought Nolde's mysticism diverted his colleague too far from the formal issues of modernism. That same tendency led Nolde to make a grave error in 1933, when he stated that his Expressionist painting was a genuine expression of the "German soul". He was rudely awakened from this dream by the Nazis, who the following year delivered Nolde's paintings over to the derision of the philistines.

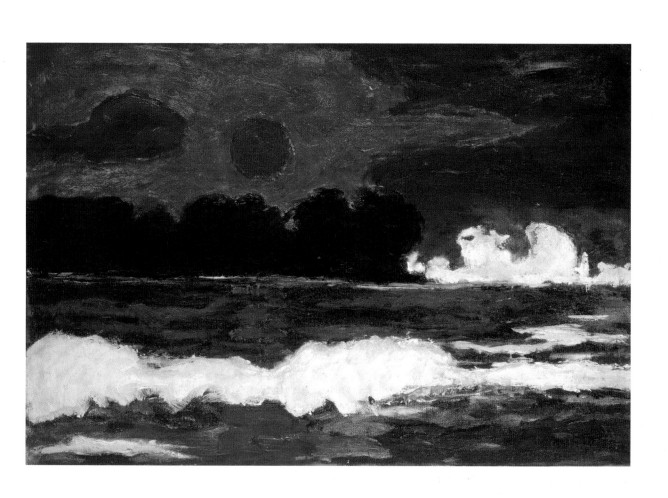

palau triptych

Oil on canvas, 119 x 353 cm (central panel 119 x 171 cm, wings 119 x 91 cm each)
Ludwigshafen, Wilhelm-Hack-Museum

b. 1881 in Eckersbach,
d. 1955 in Berlin

The Expressionists enthusiastically adopted the modern aesthetic of individual creativity, which implied that artists view the world solely from the standpoint of their own ego or self. If one of the leading protagonists of this aesthetic, Paul Gauguin, shifted the scene of nature suffused by the artist's ego into an exotic realm, this was because here life seemed to run its course unaffected by the conflicts of civilization. Max Pechstein, too, took this road. In his eyes the carved and painted roofbeams from the South Pacific island of Palau, which he and other Brücke artists studied at the Dresden Museum of Ethnology, embodied an archetypal unity of art and life. They seemed to reflect, in a different way, just what the group had pursued during their carefree months on the Moritzburg Lakes: a utopian alternative to the perverted industrial world. And perhaps these indigenous carvings affected Pechstein all the more because he was the first Brücke artist to forsake quiet Dresden for the big city of Berlin. Coloured by his idealistic attitude, he could say of them: "I see the carved idol images, into which trembling piety and awe of the incomprehensible forces of nature have impressed [their makers'] hope and terror, their fear and their submission to an unavoidable fate."

Pechstein was only acting consistently when in April 1914, like Nolde the previous year, he set off for the South Seas to spend a few years in the Palau Islands. But he was surprised there by the war, was taken prisoner by the Japanese, managed a daredevil escape, and returned as a coal trimmer on freighters by way of Hawaii, New York and the Netherlands to Germany – where he was immediately inducted into the army. The horrors of the front lines proved too much for

him. He suffered a nervous breakdown and was released to return to Berlin. Now Pechstein began to distil his travel memories into the compelling composition of his Palau triptych, unfolding a peaceful world in face of a murderous civilization, suppressing the "savage" manner of the Brücke period in favour of a tranquil harmony.

Within the continuous landscape panorama, various decoratively stylized, not so much expressive as neoclassical scenes spread across the central panel and two flanking wings. Depicted on the left wing is a family of islanders, father, mother and child, in a boat. The central panel is likewise dominated by a trio of seated figures, who together with a fourth, standing person turn to the three male figures in a boat opposite, two of whom occupy the right-hand wing and one still on the middle panel. The substantially emphasized motifs of water, earth and air, and correspondingly, fish, human beings and birds, take up this symbolic triad form. Pechstein interpreted Palau – as Gauguin had done Tahiti – in terms of his own Romantic expectations, as a counterimage to "materialistic" Europe, an ideal paradise for fishing, swimming and enjoying oneself, rather than seeing the historical reality of an island that was part of a colonial empire.

After the war Pechstein, like Heckel and Schmidt-Rottluff, was a founding member in 1918 of the revolutionary Arbeitsrat für Kunst (Working Council for Art), and after it disbanded a short time later he remained politically engaged. He joined the League for Human Rights and helped produce propaganda for the young Soviet Union. Thus it was no surprise that when the Nazis clamped down on modern art in 1933, Pechstein was one of their first Expressionist victims.

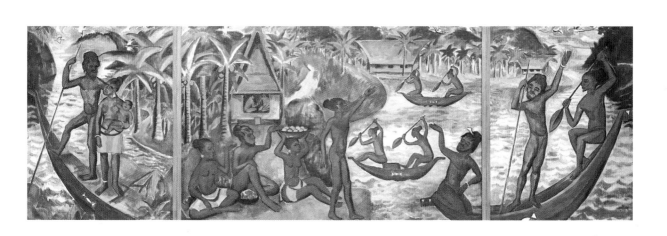

acrobats

Tempera on canvas, 110 x 75.5 cm
Essen, Museum Folkwang

**b. 1849 in Niendorf,
d. 1938 in Hagen**

As in the preceding French art of the nineteenth century, subjects from the circus, dance and vaudeville enjoyed great popularity among the Expressionists. Such performers were viewed as embodying marginal groups in society, as underdogs who, like artists themselves, sold their souls on the marketplace, not respectable yet dependent for their livelihood on the money of respectable middle-class citizens. The exaltation of dancers, the daring of artistes, seemed the perfect symbol for the "tight-wire act" of the Expressionist artist who pushed himself to the limits.

Christian Rohlfs, too, treated this motif, transforming it in a subtle way very typical of him. This is seen in his vital acrobat picture of 1916, based on contrasts and tensions, and evincing a refined, parallel composition. Against the bright red background, the pair are depicted in complementary poses that form, as it were, a single, rotating comprehensive figure. The motif employs every possibility of equilibrated, graceful movement – upright and head down – to convey an impression of great vitality. The figures are elongated almost to the point of mannerism, with the main accent on heavy contour lines and overlapping picture planes, whose transparency is achieved through the tempera technique Rohlfs began to develop about 1913. This gives the figures an airiness that belies their physical massiveness, convincing us that it was not acrobats as individuals with whom the artist was concerned but abbreviations or ciphers for movement per se, archetypal forms in motion such as those seen in ancient Mycenean vase paintings. The graphically textured paint surface of the background reveals the influence of Fauvist colour field painting, which Rohlfs had intensively studied, as well as inspiration from Emil Nolde, whom he befriended in 1905 and 1906 in Soest.

Rohlfs was what is known as a late developer. Due to a serious injury that eventually necessitated a leg amputation, the son of a Holstein farmer was confined to his bed for two years. A fellow Holsteiner, the author Theodor Storm (1817–1888), suggested he go into painting. Rohlfs had almost turned fifty before he saw Impressionist art for the first time, in 1897 in Weimar. Then Henry van de Velde (1863–1957), the Belgian architect and then-director of the Weimar School of Decorative Arts, introduced him to the art patron Karl Ernst Osthaus, who in 1901 offered Rohlfs a post at the Folkwang Museum then being built in Hagen. There he became acquainted with French Post-Impressionism and Pointillism as well as with van Gogh. Yet the decisive impulse to strike out into uncharted territory came from Edvard Munch, whom Rohlfs met in 1904.

A highly productive artist, Rohlfs began increasingly to sympathize with the avant-garde currents in Germany, and from 1912 at the latest, he could be called an Expressionist – a representative of that version of the style that drew its expressive force primarily from colour values, in his case initially brilliant, then increasingly subdued, as it were washed out. In 1906 the Brücke artists saw Rohlfs's work in the "Third German Arts and Crafts Exhibition" in Dresden. They considered inviting him to become a member, but Nolde, for obscure reasons, objected.

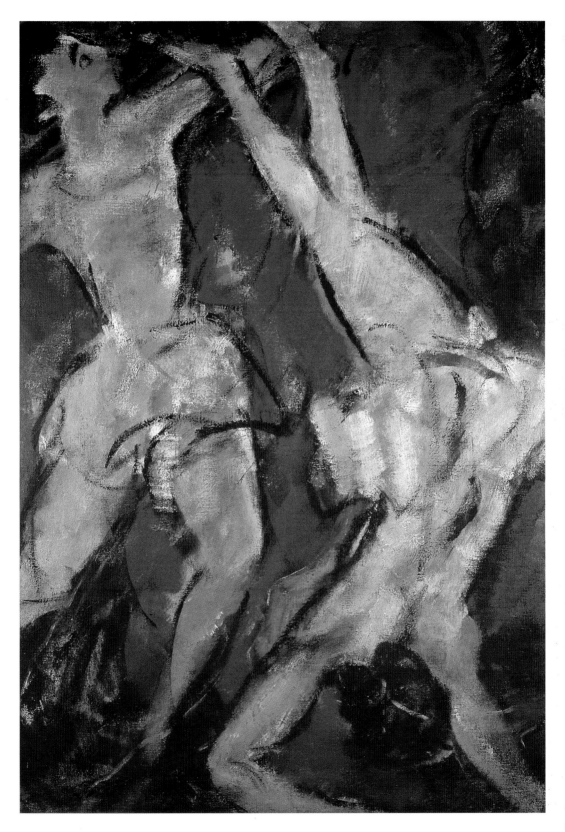

standing мale Nude (self-portrait)

Pencil, watercolour, white tempera, 55.7 x 36.8 cm
Vienna, Graphische Sammlung Albertina

b. 1890 in Tulln (Lower Austria)
d. 1918 in Vienna

Alongside Oskar Kokoschka, Schiele was the most prominent personality in Austrian Expressionism. He was repeatedly supported by the famous Gustav Klimt (1862–1918), who recognized Schiele's talent early on. In the short period from 1906 to 1909, while still a student at the Vienna Academy, Schiele passed rapidly through various creative phases, from a dry, nondescript academic style through an adaptation of decorative Art Nouveau à la Klimt to a radical formal vocabulary of great expressive force, including figurative distortion and a vehement gestural paint application.

By 1910 Schiele had arrived at his inimitable style. His work was dominated by only a few motifs, centring on the portrait and the nude. Yet, to cite Dietmar Elger, "unlike the other Expressionists, [Schiele] did not attempt to read physiognomic content from the face of his models alone. With Kokoschka, the play of the hands was itself often a more eloquent testimony than the face of the person portrayed. Schiele now made the entire body and every limb into equal bearers of artistic expression." Generally Schiele did without any indication of interior space or landscape surroundings, concentrating solely on the hypersensitive lineaments of the human body.

On August 25, 1913, the artist noted in a letter: "Mainly I now observe the physical motion of mountains, water, trees and flowers. Everywhere one is put in mind of similar motions in the human body, similar stirrings of pleasure and pain as in plants ..." In many of his portraits and self-portraits this observation appears reversed, in that the human figure takes on a plantlike character – not, of course, rendered in the elegant, sinuous lines of Art Nouveau but with a nervous,

evocative, hesitant, as it were splintered contouring that lends the figure an association with frozenness, desiccation, crippling.

In the present large-format portrait, the artist's naked torso rises like a leaning tree stump though the vertical format, the right arm, in contrast, extended stiffly into the horizontal, only to abruptly turn down at the joint like some tree branch struck by lightning. On this bizarre physical framework sits a masklike skull with a face distended into a scream. With unprecedented expressive radicality, the potential of experiencing one's own mirror image is transformed into an artifice that verges on hallucinatory self-insight. The shaping of form becomes an extreme experience, the line becomes a thin, sharp, often cutting edge that dissects and, avoiding no dissonance, penetrates into the no-man's land of the empty plane.

Despite this verve, economy of means is maintained. There is not one line too many or one too few. The creaturely aspect of the human image is worked out to the full, an existentialism reminiscent of late-Gothic images of mercy, recalling the tortured body of the suffering Christ.

In 1912 Schiele was accused of "disseminating pornographic drawings" and given a prison sentence. His art triggered hostilities from many quarters, yet a small, committed group of supporters made possible exhibitions and sales – if more in Germany than in Austria – of the short-lived artist's work.

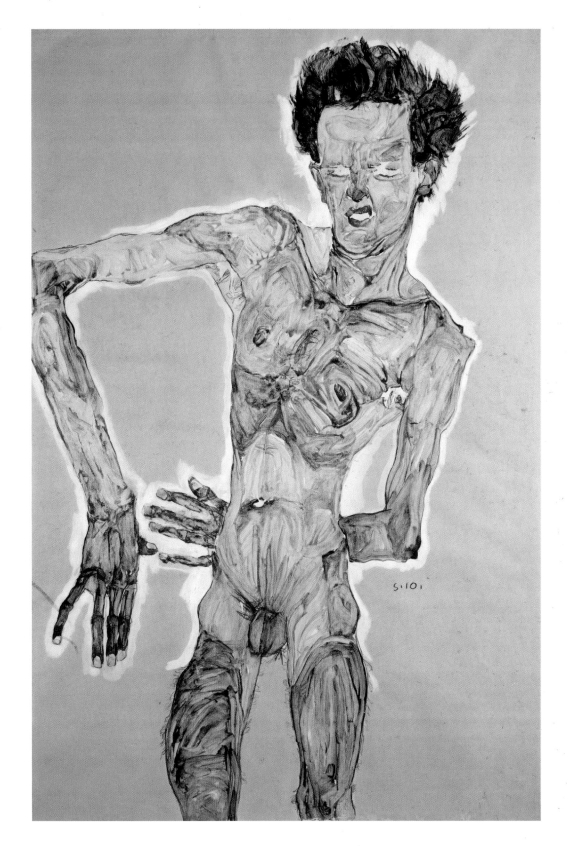

portrait of rosa schapire

Oil on canvas, 84 x 76 cm
Berlin, Brücke-Museum

b. 1884 in Rottluff (near Chemnitz),
d. 1976 in Berlin

Karl Schmidt (who in 1905 added the name of his birthplace, Rottluff, to his own) was not only the youngest Brücke artist but the one who retained the most autonomy during his membership in the group. Even in 1910, when a decidedly collective Brücke style developed, the character of his works remained unique. Schmidt-Rottluff went his own way whenever possible, for instance not taking part in the group's excursions to the Moritzburg Lakes outside Dresden but remaining faithful to the village of Dangast in Oldenburg province. "There are almost no theoretical statements by him," notes Lothar-Günther Buchheim. "In contrast to Kirchner he never subjected his style to written analysis. The few letters and notes … were destroyed in the last war, when his Berlin apartment with about 2000 drawings and many watercolours and paintings went up in flames."

Schmidt-Rottluff's beginnings around 1905 were marked by a monumental Impressionism, rapidly executed in heavy impasto with an excited, expressive touch inspired by van Gogh and often making use of the palette knife. After a visit to Nolde on Alsen island in 1906, that artist's influence also made itself felt. From about 1909, Schmidt-Rottluff's Dangast landscapes began to show a change in style. Expansive, daringly juxtaposed areas of thinned, unmixed colour now spread across the canvas, whose white showed through in places and whose grainy texture determined the surface character of the image. The forms increasingly grew in size, and compositional lines resulted from the intersection of separate colour fields. A short time later came a framework of black contour lines, as seen in the *Portrait of Rosa Schapire.*

Schmidt-Rottluff had met Rosa Schapire, a Hamburg art historian and passionate supporter of the Brücke, in 1907. She furthered him unreservedly, propagating his art in numerous articles, cataloguing his prints, purchasing many works. Schapire commissioned the young painter to furnish a room in her apartment (which was later destroyed), for which he designed virtually everything, from murals to furniture, carpets and utilitarian objects. Schmidt-Rottluff portrayed his patron a total of four times between 1911 and 1919. The first of these portraits, now in the Brücke-Museum, has become the most famous, and was one of the earliest Schmidt-Rottluff ever executed. The composition is a half-length, format-filling depiction of the artist's friend, seated in an armchair. Her head under the broad-brimmed hat rests musingly on her left arm. In contrast to this calm pose, the colour veritably explodes, accented by energetic brushstrokes and broad expanses. The predominant brown gradations and the green of the dress set a complementary contrast to and amplify the light red. The raised arm in front of this red ground leads the eye to the reddish-violet face with its brilliant blue eyes.

Schmidt-Rottluff's brief involvement with French Cubism in 1912 lent his subsequent paintings a greater succinctness that, it must be said, occasionally slipped into the merely iconic. In about 1914 he began to supplement this style with impulses from exotic, blocky wood sculptures, lending his portaits an African look. After the First World War Schmidt-Rottluff reverted seamlessly to the themes of the Brücke period, and in spite of many variations, he continued to cultivate the Expressionist gesture to a ripe old age.

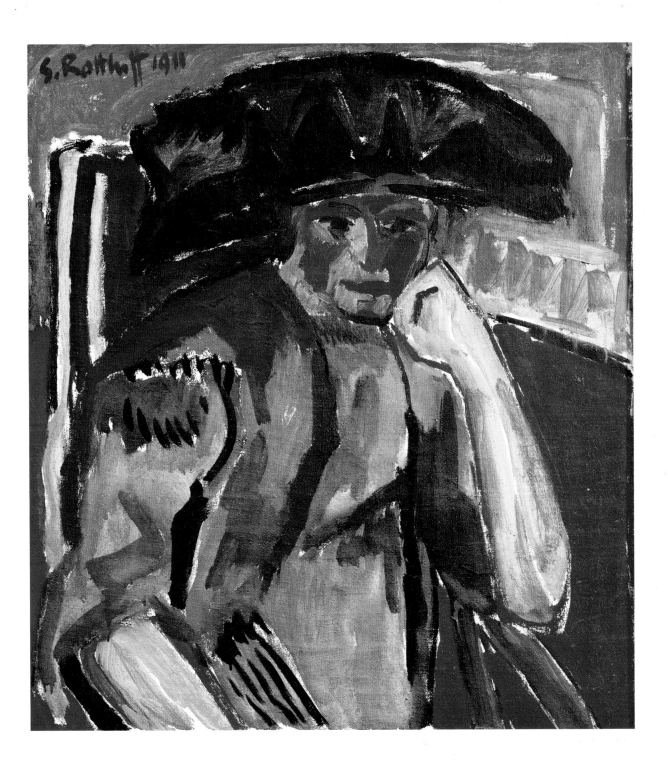

тhe Red Gaze

Oil on cardboard, 32.2 x 24.6 cm
Munich, Städtische Galerie im Lenbachhaus

b. 1874 in Vienna,
d. 1951 in Los Angeles

The composer Arnold Schoenberg, who had been in at the beginnings of the Blauer Reiter group, began painting in 1907 in the hope of making his mark in this metier as well. He received brief instruction from Richard Gerstl (fig. 26). Launching at that period into atonal music, in art Schoenberg abandoned all of the superficial illustrative tasks of painting, including that of depicting the face. "I have never seen faces, but, because I have looked people in the eye, only their gazes," stated Schoenberg. This tendency was also reflected in his painting titles, such as *The Red Gaze*.

Here the human visage is dissolved into schematic, diffuse colour structures from which the eyes "are directed like mirrors of disturbed souls at the affected viewer …" The heads seem to drown "in the surrounding colour field" and yet emerge from this maelstrom "like visions of horror," as Peter-Klaus Schuster put it, or like mental precipitations from the depths of a dream. These fantasies rely to some extent on the palette of a Robert Delaunay or the Fauves; there are a few points of contact with Gerstl and Kokoschka's painting of the day; and there is surely an inner affinity with the visions of Munch (fig. 10). The immediate catalyst for these ghostly faces may well have been Gerstl's suicide. Living in the same house as Schoenberg, Gerstl hung himself in November 1908 after breaking off his relationship with Mathilde Schoenberg.

But it would be mistaken to interpret such depictions as *The Red Gaze* solely in biographical terms. There was a larger, Symbolist conception behind them. From about 1908 onwards, Schoenberg devoted himself to the idea of an interdisciplinary work of art on stage, a true synthesis of the arts rather than a mere addition of their means. From these considerations he derived a definition of colour, gesture, movement, light and music as vehicles of meaning in their own right, which conveyed not "alien" content but their own intrinsic autonomy, their suggestive force, their expressiveness, and not least, their dissonances. Human beings and their image appeared in this context as de-individualized prototypes, embodying universal forces and energies.

Schoenberg's friendship with Kandinsky dated to early 1911. Their respective notions about the essence of art revealed many points in common. Their interest in then-emergent theosophy out of cultural pessimism and an opposition to materialism resulted in a parallel search for the ineffable, metaphysical, purely spiritual. In Schoenberg's oils and watercolours Kandinsky detected the presence of a kindred spirit. Franz Marc and especially August Macke, in contrast, were sceptical. The latter described Schoenberg's faces as "green-eyed waterlogged breakfast rolls with an astral gaze". Yet it cannot be gainsaid that Schoenberg's *Harmonielehre,* published in 1911, had a considerable influence on the Munich circle of the Blauer Reiter.

To cite Kandinsky's opinion: "We see that in every picture by Schoenberg the inner desire of the artist speaks in the form suited to it. Just as in his music … Schoenberg does without the superficial (i. e. the harmful) in painting and goes by a direct path to the essential (i. e. the necessary) … I would very much like to call Schoenberg's painting *sheer painting*."

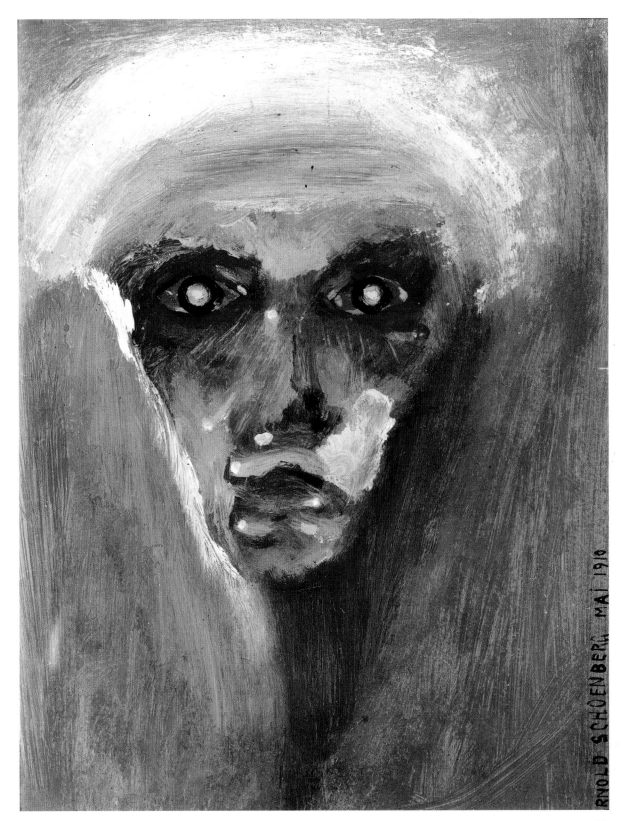

self-portrait

Tempera on paper on cardboard, 51 x 34 cm
Munich, Städtische Galerie im Lenbachhaus

b. 1860 in Tula, d. 1938 in Ascona

Marianne von Werefkin came from a prosperous Russian aristocratic family who had close ties with the czar's court. Her mother, herself a painter, approved of her idea of becoming an artist from the beginning. After receiving private instruction, von Werefkin attended art school in Moscow and, from 1886, spent ten years as a private pupil of the renowned history painter Ilya Repin (1844–1930) in St. Petersburg. In 1888, apparently in connection with a tragic affair with a young doctor, she received a gunshot wound that crippled her right hand. Yet thanks to enormous will-power and arduous training she learned to handle brush and pencil again, and with great success – in academy circles she was celebrated as a "Russian Rembrandt". The year 1891 brought an encounter that would have great consequences for her life. She fell in love with a young, penniless officer by the name of Alexei Jawlensky. Since marriage was precluded for reasons of status, the pair moved abroad, arriving in Munich in 1896. There, on Giselastrasse, von Werefkin brought into being a salon that soon became a gathering point for intellectuals and artists, especially Russians. Around 1900, inspired by the early-nineteenth-century Romantic group known as the Nazarenes, she formed a community of artists which was soon joined by Kandinsky. She worshipped Romanticism, and revered French Symbolist literature. The Symbolistically tinged painting of the Nabis also impressed her. In 1907, after a ten-year break in which she concerned herself primarily with her partner's career, she returned to painting. In 1909 she became a founding member of the New Artists Association of Munich, but did not go along with the Blauer Reiter when they split off in 1911, and thus stood between the two camps.

Her *Self-Portrait* at the Lenbachhaus in Munich was done during the happy years of her close artistic contacts with Kandinsky and Gabriele Münter. The energetic pose, striking facial features, and extravagant headgear reveal much about the worldly-wise and shrewd personality of the sitter. The strong colours applied in broad brushstrokes and the continuous contour holding together the elongated forms reflect the influences that held most importance for von Werefkin: the Nabis, and the "soul painting" of Edvard Munch. Beginning from such points of departure, the artist augmented her colour range to include those brilliant contrasts typical of Expressionism. Yet the configurations were not yet abstracted to the point that they became subordinate to the colour, as in the case of many Brücke paintings. Line continued to play the key role in defining the composition. This is why the pictorial field does not take on the extremely flat effect seen, for instance, in Jawlensky's portraits. A noticeable traditionalism, combined with a certain mystical, Symbolist undertone, apparently prevented von Werefkin – who understood women's role principally as one of communication – from putting into practice what she so eloquently advocated theoretically, namely the step to abstraction. She was probably material in acquainting Kandinsky with the anthroposophical teachings of Rudolf Steiner and the early theosophical writings of Madame Blavatsky, which furthered his turn to pure, spiritualized abstraction.

In 1920, von Werefkin and Jawlensky separated in Switzerland, where they had gone to escape the war. She died impoverished in Ascona in 1938.

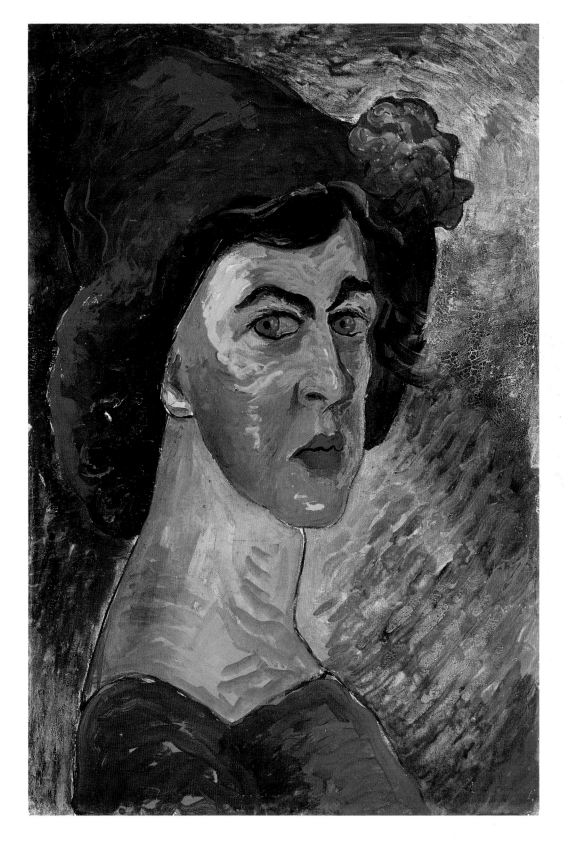

© 2004 TASCHEN GmbH
Hohenzollernring 53, D–50672 Köln
www.taschen.com

Editing: Uta Grosenick, Cologne
Editorial coordination: Sabine Bleßmann, Cologne
Design: Sense/Net, Andy Disl and Birgit Reber, Cologne
Production: Ute Wachendorf, Cologne
English translation: John Gabriel, Worpswede

Printed in Germany
ISBN 3–8228–2126–8

Photo credits:
The publishers would like to express their thanks to the archives, museums, private collections, galleries and photographers for their kind support in the production of this book and for making their pictures available. If not stated otherwise, the reproductions were made from material from the archive of the publishers. In addition to the institutions and collections named in the picture descriptions, special mention is made of the following:

ARTOTHEK: p. 7 (left), 8, 14 (left), 16 (right), 21, 35, 37, 39, 41, 43, 45, 47, 49, 53, 63, 65, 67, 69, 71, 73, 75, 77, 83, 87, 93, 95
© Photothèque des Musées de la Ville de Paris: p. 11
© Musée Calvet, Avignon: S. 13 (photo: André Guerrand)
© Archiv für Kunst und Geschichte, Berlin: p. 19, 20 (right), 22 (right), 23, 51, 61, 79, 85, 89, 91, 92
© Stiftung Archiv der Akademie der Künste, Berlin: p. 24 (left)
Bildarchiv Preußischer Kulturbesitz, Berlin
© Hamburger Kunsthalle: S. 81 (photo: Elke Walford)
© Saint Louis Art Museum, St. Louis: p. 29, 33

Page 1
WASSILY KANDINSKY
Cover for the catalogue of the first "Blauer Reiter" exhibition, based on an Indian-ink drawing

Page 2
AUGUST MACKE

<u>Milliner's Shop</u>
1914, Oil on canvas, 60.5 x 50.5 cm
Essen, Museum Folkwang

Page 4
OTTO MUELLER

<u>Two Sisters</u>
n. d., Distemper on burlap, 90 x 71 cm
St. Louis, Saint Louis Art Museum,
Bequest of Morton D. May